THE FABERGÉ EGG.

OTHER BOOKS BY ROBERT UPTON

A Golden Fleecing

Amos McGuffin Mysteries
Who'd Want to Kill Old George?
Fade Out
Dead on the Stick

THE FABERGÉ EGG·ROBERT UPTON

AN
AMOS
McGUFFIN
MYSTERY

E. P. DUTTON
NEW YORK

Publisher's Note: *This novel is a work of fiction.
Names, characters, places, and incidents either are the product
of the author's imagination or are used fictitiously, and
any resemblance to actual persons, living or dead,
events, or locales is entirely coincidental.*

*No part of this publication may be reproduced or transmitted
in any form or by any means, electronic or mechanical, including
photocopy, recording, or any information storage and retrieval
system now known or to be invented, without permission in writing
from the publisher, except by a reviewer who wishes to quote
brief passages in connection with a review written for inclusion
in a magazine, newspaper, or broadcast.*

Published in the United States by E. P. Dutton,
a division of NAL Penguin Inc.,
2 Park Avenue, New York, N.Y. 10016.

Published simultaneously in Canada
by Fitzhenry and Whiteside,
Limited, Toronto.

Library of Congress Cataloging-in-Publication Data
Upton, Robert.
The Fabergé egg : an Amos McGuffin mystery / by Robert Upton. —
1st ed.
p. cm.
ISBN 0-525-24692-4
I. Title.
PS3571.P5F28 1988
813'.54 —dc19 88-11944
CIP

Designed by David Lui

1 3 5 7 9 10 8 6 4 2

First Edition

To a classic beauty

1

When McGuffin returned to San Francisco following a lengthy Caribbean case, he learned that his daughter and ex-wife had disappeared. He didn't learn this disturbing news all at once. It accumulated slowly, against all odds, like black clouds gathering on the horizon despite a sunny forecast.

He certainly had no inkling of it when he stepped into Goody's saloon only a few hours after touching down at San Francisco International. It was ten o'clock, the cocktail crowd had long since departed, leaving the spartan saloon to the lawyers, cops, politicos and journalists who were its woof and warp. If there was anything important going on at City Hall or the Hall of Justice, the chances of hearing about it first at Goody's were excellent. And to Amos McGuffin, a San Francisco private investigator, such gossip was the stuff of commerce. But by the time McGuffin had made his way down the long, scarred, mahogany bar, shaking hands and explaining his recent

absence, he was still an unemployed private eye. He took his usual place under the television at the end of the bar and waited while Goody waddled apelike down to him.

"So how was the Medifuckin'terranean?" Goody growled. A San Franciscan for more than fifty years, Goody saw no reason to leave the city and disapproved of those who did.

"It was the Carifuckin'bean," McGuffin answered.

"The same thing," Goody said, reaching unbidden for the bottle of Paddy's Irish whiskey on the shelf in front of the cracked yellowing mirror. Then with a thick, broken-knuckled hand, the result of having served as bouncer as well as bartender for most of his forty years in the business, he snatched a glass from the rinse water and slammed it and the bottle down on the bar. "So now the case is finished I suppose you're gonna get pissed."

"I may have a whiskey or two before resuming my usual occupation," the detective answered. For although McGuffin never drank while on a case, his consumption between assignments was the stuff of legend in San Francisco. And although Goody's fortunes derived from the sale of alcohol, the wrath engendered in him by those who abused it was a fearsome thing. It was one of the things that made Goody's an unusual bar. Along with the ancient spittoons and wooden card tables scattered over the black and white octagonal tiles and the tin ceiling. Goody's had changed little in forty years and had been dusted even less.

Goody splashed whiskey into the glass, then watched as McGuffin drank, carving straight lines and square angles in the air before snapping it down. The way McGuffin drinks, it's a thing of beauty, Goody had often observed. Until his fifteenth or twentieth, then he gets a little sloppy.

"Another," McGuffin said, sliding the glass across the rough wood.

Goody poured him a shorter drink this time and watched as the ritual was repeated. When the glass was

half-finished, McGuffin placed it on the bar, ran the back of his hand across his mouth and then stood very still while the whiskey worked its magical way through his body. It seemed to Goody that a slight smile formed at the corners of McGuffin's mouth as he settled back onto his stool.

"Any messages?" the detective asked.

Goody rummaged under the bar and came out with a handful of scribbled notes. McGuffin picked through them while Goody went off to pour another round for the knot of drinkers at the opposite end of the bar. There were several messages, none of them of any professional consequence. Sam Wo wanted him to pick up his shirts and Mrs. Begelman wanted him to pay his phone answering service which was more than two months overdue. And Elmo who owned the *Oakland Queen,* the ferry boat cum offices where McGuffin resided free of charge in return for security duties, wanted to know where he had been for the past few weeks. McGuffin pushed through these quickly, searching for one from his ten-year-old daughter, Hillary, who was to have been informed on Monday whether she or her archenemy Rose D'Amato was to play Queen Isabella in the school play. The absence of this message was the first dark cloud on the horizon.

The second cloud appeared a few minutes later when McGuffin phoned his daughter and got no answer. He walked slowly back to the barstool and sat staring at his puzzled countenance in the yellowing mirror.

"You want another one?" Goody called, walking toward McGuffin. McGuffin shook his head.

"What's wrong?"

"Did Hillary phone with a message while I was gone?"

"No," Goody answered. "Was she supposed to?"

"Yes, she was," McGuffin answered. "And I just phoned Marilyn's apartment and nobody's at home. Almost eleven on a school night and Marilyn's got her out

someplace," McGuffin said uncertainly. His ex-wife could be flaky, but not where Hillary was concerned.

"I'm not surprised," Goody, who had another opinion of Marilyn, put in. Like Zelda Fitzgerald, Marilyn had decided late in life to become a ballerina, but had given it up after several months. During that time, when Hillary was only five or six, Marilyn often left her at the bar while she attended lessons, knowing that McGuffin would come by sooner or later to relieve Goody of his baby-sitting duties. As a mother, Goody thought, Marilyn McGuffin was an excellent argument for abortion. "What's she doin' now that she ain't dancin' no more?" Goody asked.

"She's become an actress."

"No shit—?"

"Why not? She's tried everything else. She was a painter when I married her. Then she became a poet and then a singer. Only now she says she's finally found her true vocation."

"So maybe she took the kid and went to Hollywood to be in the movies," Goody suggested.

"Too old," McGuffin said. "Actresses over thirty aren't allowed in Hollywood. That's why they have guards at the studio gates, like fruit inspectors at the state line."

"If they're supposed to be keepin' the fruits outta Hollywood they ain't doin' such a good job."

"Yeah," McGuffin said, glancing at his watch.

"Don't worry, they probably just went out to get ice cream or somethin'," Goody assured the detective.

"Goody, we're parched!" Judge Brennan called.

"Yeah, yeah," Goody muttered, as he turned and started down the bar.

McGuffin stared at the mirror without seeing himself. Goody was right, he knew. Marilyn had taken her out for ice cream or something like that. At ten-thirty at night? he asked his reflection.

"Shit!" McGuffin said, gathering up his messages and jamming them into his jacket pocket. There would be nei-

ther rest nor drink until he had the answer to these questions.

Goody looked up from the beer he was drawing and called, "Where ya goin'?"

"To check on my daughter," McGuffin answered, continuing purposefully to the door.

"Hey, Amos, come and have a drink!" Judge Brennan called.

"Later," McGuffin said, stiff-arming the door.

Outside at the curb, Sullivan the cop was hefting his bulk out of a cab, followed by Danny, the only drunk Goody allowed in his place, solely as an example to those like McGuffin who were not beyond redemption. The big cop pulled Danny to his feet, propped him against the car and then went through Danny's pockets for cab fare. He gave the driver a ten and told him to keep the change as McGuffin slid into the backseat. Seeing McGuffin in the cab, Danny blinked uncertainly.

"Hey, Amos, aren't you comin' in?" Danny asked.

McGuffin shook his head. "I've had enough."

"Okay," Danny said, spinning and nearly falling. Sullivan caught him and together they lurched drunkenly toward the door. "Funny thing," McGuffin heard Danny say, before the cab pulled away. "I don't remember McGuffin bein' with us earlier tonight."

McGuffin gave the driver Marilyn's address in North Beach and he wheeled the car quickly into traffic. He turned right at the corner, then left after a few blocks, into the boutiquey Jefferson Market area, then up onto Broadway, the poor white way (sex comin' atcha, snap crackle and pop, bottomless topless all-nude and live), sleazy thugs standing in the doorways like moray eels, waiting to pounce on passing tourists. They turned right at the Condor Bar, home of Carol Doda, the topless dancer who started it all, then right again on Grant Avenue, Main Street to the Beat Generation, forgotten but not entirely gone. The detective spied a few gray-bearded veterans as he rolled slowly past the Trieste coffeehouse,

acid-shocked warriors of the Haight-Ashbury and Woodstock campaigns, now sharing an uneasy truce in North Beach with the Yuppie occupation forces. I've witnessed a lot of history and never been a part of any of it, McGuffin thought. Hell, until *Time* magazine gives it a name and sums up the decade, I don't even know what I've missed.

The apartment McGuffin had once shared with his ex-wife and daughter was on the top floor of a three-story Victorian in a narrow alley within the shadow of Coit Tower. McGuffin pointed out the house and the driver glided to a stop at the front step. He paid the driver and slipped quickly out of the car and skipped up the several stairs to the matching pair of wooden doors. He pressed the buzzer above his own name (Marilyn had chosen to keep it for Hillary's sake) and waited for the answering buzz that would release the lock. Getting no answer he pressed the button again, for a long time. A moment later the door to his right was opened by Mrs. Della, the landlady, clutching a man's plaid bathrobe over her ample bosom.

"They aren't home," she said.

"Where are they?" McGuffin demanded.

"How should I know? I wouldn't even know they were gone if I didn't happen to glance out the window and see them getting into the car."

"Whose car?"

She shrugged. "Some man—I never saw him before."

"What did he look like?"

"Old," she answered uncertainly. "I couldn't tell, it was dark."

"Dark—? When did this happen?"

"About midnight," she said hesitantly, then nodded vigorously. "Yeah, Sunday night about midnight."

"You just happened to glance out the window at midnight?" McGuffin questioned.

"Something woke me up."

"What?"

"I'm not sure. Voices, I think. Some sort of commotion."

"What sort of commotion? Were they being forced into the car?" McGuffin asked, backing her up against the door frame. Private investigators accumulated vengeful enemies like parking tickets. Most of them cooled down after five to ten in San Quentin, but there was always the occasional psychopath who lived only for revenge and that fact was never far from the detective's mind.

"Of course they weren't being forced," the landlady protested. "Don't you think I would have called the police if—?"

"Are you sure?" McGuffin pressed.

"Of course I'm sure," she answered, faintly indignant. "I mean Hillary may have been acting up a bit, but you know how it is with kids."

"No, I don't. So please, Mrs. Della, tell me exactly what you saw," McGuffin insisted, enunciating precisely.

"Well, she was sort of pulling away, like she didn't want to go, but Marilyn managed to pull her into the car okay and then the old man shut the back door and that was the end of that."

"And you didn't think this was suspicious? You didn't think the old man might have been forcing both of them into the car?" McGuffin asked, pressing closer to the old lady.

"I never thought—" she began, as a sudden look of fear flashed in her eyes.

"Never mind. Do you have the key?"

"I don't like to go in when she's—"

"Give me the key," McGuffin ordered.

She dug into her robe and came up with it. McGuffin opened the door, stepped over a pile of mail and took the carpeted stairs three at a time. He moved the length of the apartment in several long strides and threw open the door to Hillary's room. Nothing seemed amiss. The unmade bed was cluttered with stuffed toys and school-

books, but the rest of the room was neat and orderly, as was Hillary's wont.

The next bedroom was Marilyn's. And although it was not so neat as her daughter's, it scarcely looked as if anyone had been forcibly abducted from there recently.

"All the other times she tell me when she goes," Mrs. Della complained as she pulled herself over the top stair. "Why don't she tell me this time?"

"I don't know," McGuffin said, going into the bathroom. Both toothbrushes were missing, a good sign. Either that or an unusually considerate kidnapper. He pushed past the stout landlady and returned to Hillary's room. Her dress with the ruffled hem, the one he had bought for their first brunch at the St. Francis, was gone from her closet, as well as two or three of the others he could remember. All of the dresses that remained seemed much too small for her, except for a few light summer things. Her brown loden coat with the plaid lining was also missing, the detective noticed.

"What are you looking for?" Mrs. Della asked, as McGuffin crossed to the chest of drawers. Most of her underwear and socks were gone from the top drawer, as well as her jeans and sweaters.

Ignoring the landlady for the moment, McGuffin returned to his ex-wife's room and yanked the closet door open. The Burberry raincoat she had bought in London during the pound crisis was gone, but the ratty raccoon remained, like a forgotten animal at a defunct zoo. Marilyn, who seldom held a straight job, had a few dresses, most of which seemed to be hanging in their place—except the black sheath that set off her long lean body so well. The red silk dress, too, was missing, as well as the wool knit. Most of the sweaters and pants that she favored were still in their drawers, McGuffin saw when he went through the chest, but the underwear drawer had been cleaned out.

"Did she have a suitcase with her?" McGuffin asked the landlady.

Mrs. Della shook her head helplessly. "I couldn't see."

It looked as if Hillary had packed her winter clothes and left her summer clothes, while her mother had taken three dresses and a raincoat. The detective didn't know what to make of it. Until he spied the yellowing newspaper clipping lying on top of the chest of drawers.

PRIVATE INVESTIGATOR
SLAIN IN OFFICE

ran the aged but familiar headline. McGuffin's face paled and his hand trembled as he reached for the clipping. He glanced at it, there was no need to read it, then slipped it into his jacket pocket and turned to Mrs. Della.

"The man who came for them would have been in his late sixties, small, with a round face and pop eyes. Does that sound like the man who took them away?" McGuffin asked.

"It was dark, I couldn't see good," Mrs. Della answered fearfully. "I'm sorry, Mr. McGuffin."

"It's all right, I know who he is," McGuffin said, crossing to the phone on the nightstand beside the bed. He picked up the receiver and dialed the operator. "This is an emergency," he said calmly to the woman who answered. "Please put me through to the Napa Hospital for the Criminally Insane."

McGuffin made his way slowly to the night-shift chain of command until, on the third try, he found an attendant able to give him the information he required.

"Otto Kruger was an inmate here for almost eighteen years. He was released last month," the attendant informed him.

"Released!" McGuffin exclaimed. "Why, for God's sake?"

"Because it was decided by a panel of psychiatric experts that he was no longer a threat to himself or to society," the attendant answered frostily.

"Well, you can tell your panel of psychiatric experts that their harmless patient has abducted my wife and daughter. So will you please look in your file and tell me where I can find the sonofabitch!"

"I'm sorry, I'm not allowed to give out that information," the attendant replied.

"Didn't you hear what I said?" McGuffin shouted. "He has my wife and daughter! He may kill them if I don't get to them in time!"

"I'm sorry, I cannot give out—"

"Look, I can get a court order, we both know that. But that'll take time and I don't have time. So for God's sake, man, please, bend the rules just this once. There are two lives in your hands."

"I understand, don't think I don't," the attendant answered in a soothing voice. "But I have my orders."

"Fuck your orders!" McGuffin shouted, followed quickly by a dead line. "Goddamnit!" he said, slamming the receiver in its cradle.

"Mr. McGuffin—" the landlady rebuked mildly, as the detective lunged for the door.

McGuffin bounded down the stairs and fairly leaped from the porch to the alley. He ran down the alley and turned right, then sprinted down the middle of the street in the direction of Washington Square, shouting for a taxi. At the corner of Columbus and Union he slid into a stopped cab through the left door, while a young couple was entering from the right.

"Police business!" McGuffin gasped, shoving the young woman out of the cab and pulling the door shut. "The Embarcadero, as fast as you can go," McGuffin ordered.

"Hey, come back here!" the young man shouted after the departing cab.

McGuffin gave the kid behind the wheel the route to the *Oakland Queen* and the kid followed it, barely slowing for stop signs, squealing around corners and roaring down the straightaways.

"You a real cop?" the kid asked, grinning at McGuffin in the mirror.

McGuffin looked at the young man's eyes in the mirror. The kid was enjoying the excitement. "Yeah, I'm a real cop," McGuffin answered.

He skidded the cab into a near U-turn and came to a sharp stop just inches from the gangplank leading to the ferry boat. It was a neat fillip, so McGuffin gave the kid a twenty, then jumped out of the car and hurried up the gangplank. The boat was empty but the architects' offices were lighted, to ward off the vandals McGuffin was supposed to guard against, in exchange for free rent in the wheelhouse. It was scarcely dignified work for a "real cop" but it was only temporary, until he made a big score and moved into a posh suite in the financial district, he had been telling himself for more than five years. Until then he was forced to endure the landlord's insulting messages which were periodically taped to the wheelhouse door, directly over the detective's name and title. He found three of them upon his return from the Caribbean, all of which he threw away unread. However, when he got to the top of the gangway and saw an envelope pinched between the door and the jamb, he eagerly snatched it away and quickly tore it open, hoping it might be a message from Otto Kruger. Instead it was still another message from Elmo Bellini, the architect-owner and captain of the *Oakland Queen.*

> *Dear Amos,*
> *I trust you have returned rested from the Caribbean and are ready to resume your lately neglected duties as security officer aboard the—*

McGuffin opened the door to his office and apartment, dropped the note in the waste can with the others, then walked across the cabin and began rummaging through his desk drawers. He was looking for a ring of keys which he hadn't seen in years. He found several keys

to unknown locks, but not the one he was looking for. Finally he found them, hanging from a hook beside the main hatch. He snatched the ring from the hook as he pushed through the hatch and hurried down the gangway. One of these keys opened the door to the engine room, converted now to storage bins for the tenants of the boat. Not knowing what else to do with his ex-boss's files and few personal possessions after his murder, McGuffin had packed everything in a large trunk, then dragged it after him for the next eighteen years. He walked to the green hatch at the end of the main deck and then tried several keys before finally opening the hatch.

The big diesel engines were gone, replaced by rows of chicken-wire bins piled high with old records and discarded office furniture. McGuffin's bin, the only one without a padlock, was at the end of the line. Pushing through skis, crutches and abandoned appliances, McGuffin began hauling cartons aside. Miles Dwindling's ancient trunk, a turtleback affair with oak ribs, was at the bottom of the pile, wedged tightly against the bulkhead. Wisely, McGuffin had left it unlocked for eighteen years. A cracked, leather-bound appointment book bearing the faded embossed name "Miles Dwindling, Private Investigator" lay atop a sheaf of yellowed papers. McGuffin had gone carefully through the appointment book and papers some eighteen years before, hoping but failing to find some connection between his boss and a stranger named Otto Kruger. He pushed this aside and began digging through the layers of memory, like archeological strata, searching for the newspaper account of Otto Kruger's trial for the murder of Miles Dwindling.

Beyond the first layer he found a single faded photograph of a little girl with Shirley Temple curls, the only evidence of the marriage that had come apart early on, due no doubt to Miles's relentless pursuit of his profession. McGuffin had phoned her mother to tell her of her ex-husband's death, but the woman had expressed little

concern. Miles Dwindling was an honest and honorable man, a learned scholar and a wonderful conversationalist, but to her he was just a failed husband. Like me, McGuffin thought, as he plunged deeper into the trunk.

There was Miles's checkbook, showing a little over two hundred dollars in his account, a hundred and five of which was still owed to McGuffin for a week's work. Nobody could ever say Miles was on the take. He went out of the world only a little less poorer than he had come in. There was an empty wallet in the bottom of the trunk, an unused passport, a Swiss army knife, an empty shoulder holster (the district attorney's office had never returned Miles's revolver, which Otto Kruger had used to kill him), a silver humidor, a large fountain pen, a tin statue of a black crow stamped "Souvenir of Tijuana," a tarnished basketball trophy, an equally tarnished pair of captain's bars and last but hardly least, Miles's magical mystery bag.

Staring at this pathetic collection of a lifetime filled McGuffin with a great sadness. He had been pursuing Miles Dwindling's profession for more than eighteen years and he had little more than this himself to show for it. McGuffin found the Kruger file at the very bottom of the trunk, removed it and closed the lid. He would look at it upstairs in his office.

Eighteen goddamned years, he said to himself as he walked through the engine room, heels echoing hollowly on the steel deck. It was a grim joke played on a young man who had intended to be a lawyer. He had just graduated from college and intended to enter the University of San Francisco Law School in the fall. However, in the meantime he needed a summer job, so he had answered a vague but apparently harmless classified ad in the *Examiner*. He could still remember it.

> *Young man interested in*
> *the field of law, contact*
> *Miles Dwindling at....*

He had forgotten the number, but he'd never forget Miles Dwindling, lean as a plank, all suspenders and cigar, pacing about in his nearly bare, Post Street office while holding forth on the "ineluctable verities of the case at hand." There was nothing on the door to identify Dwindling or his profession, the fledging law student saw when he arrived at the given number. He knocked and a moment later the door was opened by a well-preserved older man in a striped shirt and tie, wearing a dark felt hat low over his eyes. He removed the cigar from his mouth and stared down his nose at the young man in the hall.

"Master McGuffin, I should say," were his first words.

"Yes, sir," Amos replied.

"Come in, come in," Miles Dwindling beckoned.

The air in the small room seemed yellow, whether from the cigar smoke or the reflection from the bare floor and few pieces of oak furniture. "I didn't know if I had the right place," McGuffin said. "There's no name on the door."

"Thanks for reminding me," Dwindling said, pulling the door closed after McGuffin. "I've been meaning to say something to my landlord about that for thirty-odd years."

"You've been in business that long, have you?" McGuffin asked, hoping to learn what that business was.

The "field of law," it turned out after several minutes of circumlocution, was a broad one indeed.

"That's right, I'm a private investigator," Dwindling finally admitted. He paced while McGuffin sat in the oak chair beside the desk.

"You mean you want somebody to take pictures of people in motel rooms and repossess cars, stuff like that?" McGuffin abruptly inquired.

A look of grave concern crossed the old man's face. He stopped pacing and placed his cigar on the edge of the oak desk. It was burned uniformly on four sides, as if done by an interior decorator. "I fear, Master McGuffin," he began, notching his thumbs in his suspenders, "that

despite your sunny appearance, you harbor a dangerous Spenglerian predilection for the gloomier aspect of life. True, sometimes the private investigation business is good and sometimes it's not so good. But I assure you, Master McGuffin, it is almost always exciting."

"You mean dangerous, don't you?" McGuffin replied.

"On rare occasions," the old detective answered.

McGuffin knew better, but if the job paid well enough he might be willing to risk it for one summer. "How much does it pay?"

"Aha!" Dwindling said, reaching for his cigar. "There, I'm afraid, your Spenglerian pessimism is more than warranted."

"I have to have at least a hundred and fifty a week," McGuffin warned, hoping for one twenty-five.

"Would that I could."

"A hundred and twenty-five?"

"One hundred, which is twenty-five more than the budget allows. Plus a host of experiences that will enrich and ennoble you beyond all coin."

"I can't do it," McGuffin said, starting out of the chair.

"With the possibility of a bonus," he added, laying a hand on the applicant's shoulder.

"What kind of bonus?"

"The private investigation business is a vicissitudinous one, Master McGuffin. If a particularly lucrative assignment should come our way, I should feel morally constrained to see that you partake of it."

Knowing better, Master McGuffin eventually allowed the old detective to persuade him to take the job. He began that very evening, trailing a suspected embezzler as he made the rounds of the North Beach night spots. At about midnight, when both the suspect and McGuffin were quite drunk, the suspect got up from his table at the Matador and staggered over to McGuffin at the bar. Even drunk, the man was big and dangerous, McGuffin sensed,

as he looked up at the narrowed eyes glaring intently at him. McGuffin was ready to dive off the barstool and quit his job when the drunk smiled and asked pleasantly, "Don't I know you from someplace?"

McGuffin heaved a sigh of relief and answered, "You know, you look familiar to me, too."

"Let's have a drink," the suspect proposed, to which the detective readily agreed.

Although McGuffin had never been in the army, it was decided after the second drink that that was where they had met. And after two more it was decided that they had been close friends in dangerous times. Then, when the suspect and the detective were the last customers in the bar, the suspected embezzler threw an arm over the detective's shoulder and weepily informed him, "I got somethin' botherin' me real bad, buddy, and you're the only guy I can tell it to."

"Sure, pal, tell me about it," McGuffin urged.

The next day, Miles Dwindling sat at his desk listening with a slowly sagging jaw as his new employee read his first report, listing every penny that was stolen and where it was now hidden.

"How did you do that?" the old detective asked when McGuffin had finished.

"I don't know, I guess he just wanted to talk," McGuffin answered.

"That face, Master McGuffin, is a gift from the gods. You will go far in this business."

McGuffin smiled sheepishly. He hadn't told the old man that he was leaving in the fall. And when Dwindling's client rewarded him with an extra thousand dollars, which Miles, true to his word, split evenly with his new employee, McGuffin realized that quitting on the old man would be the hardest and cruelest thing he had ever done.

And eighteen goddamned years later I'm still at it, McGuffin said to himself as he opened the ship's door to

his office, adorned with the brass plate that had eluded Miles Dwindling for thirty-odd years:

AMOS MCGUFFIN
CONFIDENTIAL INVESTIGATIONS

With a swipe of one arm, McGuffin cleared a place on the desk and opened the Kruger file. The pages smelled damp and musty. There were several newspaper articles, along with copies of the homicide and medical examiner's report, and a legal pad filled with McGuffin's notes. He arranged the clippings in chronological order, discovered that the original report of the murder was missing, then remembered the yellowed newsprint in his pocket. He placed it on top of the pile and began to read.

PRIVATE INVESTIGATOR
SLAIN IN OFFICE

Late yesterday afternoon, as his partner was stepping off the elevator just outside the door, San Francisco private investigator Miles Dwindling was shot and killed in an apparently motiveless crime. "If I'd been there a minute sooner I might have saved him," his young partner, Amos McGuffin, wept.

McGuffin tossed the clipping aside. There was no need to read it. He knew better than anyone except the murderer what had happened that day. He had just returned from what was to have been a routine background investigation for an insurance company. A logger had lost a finger to a brand-new chain saw when one of the links gave way. He wanted ten thousand dollars for his trouble and McGuffin assumed he was entitled to it. Until he got a surprised look at the rest of the family. They were seated around a cable spool in their junk-laden backyard, eating a lunch of grits and okra, but having some diffi-

culty with the utensils. Every member of the family, down to the smallest child, was missing two or three fingers, all of them neatly chopped off by their mother with a bloody axe. This would have been the fifteenth attempt, each time under a false name, to run the old chain-saw scam.

The young detective walked slowly down the corridor, utterly depressed by the depraved greed he had witnessed that day. He was scarcely twenty feet from the door when he heard the shot and bolted for the office. He pulled open the door and collided with a small, moon-faced man with great bulging eyes.

"Let me go!" the little man hissed, but McGuffin held tight to his lapels.

When he squirmed and kicked and tried to bite, McGuffin slammed him hard against the wall, once, twice and he was out. He let him slide to the floor, then lunged across the room to his boss, slumped in his desk chair, blood staining his striped shirt from suspender to suspender.

"Hold still, I'll get a doctor!" McGuffin said, not knowing yet if Miles was alive or dead. He scrabbled across the desk for the phone, dialed the emergency number and ordered an ambulance. As he was hanging up, he saw the first glint of life in Miles's eyes. He was warning McGuffin of something going on behind him. McGuffin turned to see the little man inching his way across the floor to the gun at the opposite side of the room, near the oak coat tree where it usually hung from Miles's shoulder holster. McGuffin put himself between the little man and the gun, then raised his foot and brought his leather heel down on the man's hand as hard as he could. The scream and the feel of cracking bones underfoot cheered him up after the ordeal of the children with the missing fingers.

"Who is he? Why'd he shoot you?" McGuffin demanded, lunging back across the room to his partner.

Miles seemed to smile as he shook his head slowly

and helplessly. He tried to speak but managed only to summon up a froth of bloody bubbles and a gurgling sound. McGuffin put his ear close to Miles's mouth and strained to hear.

"...out of his bird," Miles Dwindling said weakly.

They were his last words. A second later his chin dropped to his chest and he was dead.

The ambulance attendants had to pull McGuffin off the murderer when they arrived. McGuffin had slapped him around the room for more than fifteen minutes, opening several cuts on the moon face with his new college ring, but the little man said nothing. Nor would he speak to the police or the district attorney, or the psychiatric panel that examined him. There was no evidence that the murderer and his victim had ever met or had dealings with each other through a third party. He was apparently a nut who had wandered into the office, spied the gun in its holster and decided to shoot its owner. He was unemployed at the time and living in the Europa Hotel not far from the office.

McGuffin picked up the next clipping and began to read, hoping to find some clue as to Otto Kruger's present whereabouts, but found nothing. Most of what was known about him was supplied by Immigration. He had been an officer in the German army, serving during most of the war with the occupation forces in France. He was neither a Nazi nor a war criminal, according to Immigration.

Suddenly McGuffin remembered. There had been a friend, a comrade-in-arms who had arrived in the United States several years after Kruger. The two of them had shared a house together somewhere until shortly before the murder. McGuffin had not met the man; he had testified only briefly at the sanity hearing and then disappeared. McGuffin leafed quickly through the newspaper articles until he found the one he was looking for.

* * *

19

Klaus Vandenhof, a friend who had at one time shared a house in Marin County with the accused, testified that he had not recently been in touch with his old friend and could not comment as to his state of mind.

"Klaus Vandenhof!" McGuffin repeated, going to his notes. The name was familiar. It was possible that he had investigated the witnesses' backgrounds more fully at the time than had the district attorney. Leafing quickly through his longhand notes, he found the underlined name, Klaus Vandenhof, at the top of a yellow page halfway through the sheaf of papers. Vandenhof had served as a captain in the quartermaster corps with the German occupation forces in Paris during World War II. Although he was not a member of the party, he was not allowed to immigrate until 1961, when he was sponsored by an American citizen, Otto Kruger, who had served with him in Paris. The D&B in the left margin indicated to the detective that he had ordered a Dun & Bradstreet report on him at the time, but it had apparently availed him little. He had taught languages at Marin Junior College for a year before becoming an antiques dealer, with offices in his home.

His home? McGuffin questioned. He had assumed that the house had belonged to Kruger. But no, he had purchased a house in his own name on Marin Hill Drive near San Rafael in 1961, the year he arrived in the United States. So it was really Otto who got the free room in exchange for sponsoring his old boss's citizenship application. There was no record of any mortgage on the house according to Dun & Bradstreet, and "the subject lives in a luxurious manner."

So what do you make of that? McGuffin asked himself, as he leaned back in his chair and crossed his hands over his paunch as he had often seen Miles do. Vandenhof took his old comrade in out of gratitude, then a few years later threw him out. This pissed off old Otto, so he

went out and shot a total stranger right between the suspenders? It made no more sense now than it had then.

"Unless—!" McGuffin said, reaching again for his notes.

He found what he was looking for at the bottom of the page, pressed tightly against the right edge, " '25 S." It was McGuffin's shorthand for "born in 1925 and single." Otto Kruger was approximately the same age as his roommate and precisely single. When one heterosexual throws another out of the house, it's not serious. But when a homosexual throws his lover out of the house, hell hath no fury to match. Could that have been the blow that hurtled Otto Kruger over the edge? And could McGuffin have overlooked something at that sexually innocent and youthful time that might have been significant?

Maybe Otto Kruger didn't just wander in off the street after all. Maybe he came to Dwindling's office seeking some form of redress for a broken heart. Miles tried to explain that California was a heart balm state, but even if it wasn't, there was still no remedy for breach of contract between homosexual lovers, no matter how unjust this might be. Otto blamed Miles for the unjust state of the law, grabbed Miles's gun and shot him. Of course! Miles had to have talked to Kruger for a bit in order to have come to the conclusion that he was out of his bird. If a stranger had walked in and shot him without a word, Miles would have assumed he was a professional hit man, not a crazy.

Suddenly it was all grotesquely clear. Kruger's madness had festered in the hospital. For eighteen years he lived only to take vengeance on the man who had sent him there. He had researched McGuffin's life throughout that time, just as McGuffin was now researching his. By consulting the San Francisco phone book, he knew when McGuffin had moved his office from Post to Sansome Street. By reading the papers and watching the local news on television, he had remained abreast of the detective's more notable cases. He had probably read of his marriage

to Marilyn and the birth of their daughter, Hillary, a few years later. It was unlikely, however, that he had read of their divorce, as that had appeared only in the *Law Journal*. When Kruger was released he assumed that McGuffin was still living with his wife and child in North Beach. And when he arrived there and saw the name McGuffin under the bell, he was sure that vengeance was finally about to be his.

Kruger must have talked his way past Marilyn, expecting to find me in the apartment. Then when he found out we were divorced and I was no longer living there, he came unglued. He knew he couldn't let them go because they'd tell me he was out to kill me, so he did the only thing his deranged little mind would allow. He snatched my ex-wife and my daughter. Things were happening so fast he couldn't even compose a ransom note, so he left the yellowed clipping he'd been carrying around for eighteen years, knowing I'd know who had taken them. And the fact that he had allowed them to pack a bag offered at least some hope that he didn't intend to kill them.

It's possible that he hasn't yet figured out what to do with them, McGuffin told himself. I'm the one he wants, not them. He'll have to come to me to make a trade and that's when he has to slip. I may be an accidental detective, but I've had eighteen years at it, while he's spent the last eighteen years being told what to wear and when to eat. It'll be no contest.

There was, of course, an additional scenario, which McGuffin was aware of but chose not to dwell on. Unstable as Otto Kruger was, and frustrated in his carefully laid plan, he might have already panicked and killed them. No, McGuffin said to himself as he reached for the phone. He couldn't think like that. He must assume that they were alive and focus more fully on the task of rescuing them than on anything he had ever done before.

"Operator, this is an emergency," McGuffin said. "I must have the number and the address of Klaus Vanden-

hof. He last lived on Marin Hill Drive somewhere near San Rafael."

"I'm sorry," the operator said after a moment. "That number is unlisted."

"But you do have a Klaus Vandenhof?"

"Yes, sir, we do."

"Then listen carefully," McGuffin instructed. "I'm calling from San Francisco Suicide Watch. I just got off the phone with Mr. Vandenhof. He's taken some pills. He was trying to give me his address when he passed out. Please give me that address so I can send an ambulance."

"I don't have a San Francisco Suicide Watch listed among approved emergency services, sir," the operator informed him in a singsong voice.

"We're a brand-new voluntary organization, fully endorsed by the AMA and the mayor's office. Give me that address before it's too late."

"I'm sorry, I'm not allowed—"

"Do you want his death on your conscience?" McGuffin interrupted.

"No, sir, I don't."

"Then give me the address!"

"I'm sorry, sir, I cannot give out that information. However, I can send an ambulance to that address if you'd like."

"I don't want—!" McGuffin shouted, halting abruptly. "Which ambulance?"

"Marin General," she replied.

"Go ahead, send the ambulance," McGuffin said.

He dropped the phone in the cradle and sprang for the door. He was running full tilt down the main deck, between the lighted offices, when Elmo Bellini appeared at the end of the corridor, hands outstretched.

"McGuffin, stop!" he shouted.

"Not now!" McGuffin shouted back.

When Elmo lunged, McGuffin caught him with a stiff-arm to the chest, sprawling him backwards, head over heels.

"You're fired!" Elmo shouted, as McGuffin disappeared out the door and down the gangplank.

McGuffin ran along the Embarcadero, then wove across the street between flashing headlights, halting finally at the service station on the corner where he always parked.

"Quick, my car!" he gasped to the young man behind the desk reading a comic book.

Alarmed by his customer's urgency, the kid moved quickly. He had to move two cars out of the way before he was able to bring McGuffin's to the front door. With orchestrated efficiency, the kid slipped out of the front seat and McGuffin slipped in, passing the kid a five-dollar bill in the transaction. He leaned on the horn and pulled his battered car out into the Embarcadero traffic ahead of a trail of blue smoke, scattering cars right and left. He sped along the edge of San Francisco Bay, then turned onto Marina Boulevard and headed for the Golden Gate Bridge.

At the bridge McGuffin plunged the car into a wall of dense fog, then proceeded slowly across the bay to Marin County. The outgoing lanes were crowded with revelers returning to the suburbs after a night on the town, while the fog-shrouded headlights in the incoming lanes were few and far between. He switched the windshield wipers on and glimpsed the moon glowing wet and dim through the fog billowing from under the bridge like steam from a boiling bay. When he left the bridge the fog disappeared as quickly as it had come, leaving a dry moon hanging from the sky above Sausalito. McGuffin glanced at his watch and decided it was time to make the phone call.

"Sausalito," McGuffin whispered sibilantly as he turned at that exit. He was thinking of Jack Kerouac's line at first hearing of the place—"There must be a lot of Italians living there." McGuffin didn't know about the Italians, but he knew that an Irish detective and his beautiful bride had once lived there. On a houseboat, of all places. She had insisted that McGuffin give up his apartment on

Russian Hill after their marriage and move onto her "Art Barge," as McGuffin called it. It was ironic, McGuffin often thought, that a man who didn't like boats should have spent so much of his life living first on a Sausalito houseboat and now on a San Francisco ferry boat. But the *Oakland Queen,* McGuffin thought, remembering Elmo's parting words, may be my last boat.

He put the car into a shallow dive, spilled out onto Bridgeway and raced along the edge of the bay until he spied a phone near the Trident Restaurant. He skidded to a stop and jumped quickly out of the car. He dropped a coin into the box, dialed Information for the number of Marin General Emergency Room, then quickly dialed the number he was given.

"Emergency," a woman's harried voice announced over the background din.

"This is Dr. Anderson," McGuffin said. "You dispatched an ambulance for my patient Klaus Vandenhof—?"

"Yeah, a few minutes ago. We're a little backed up here, Doctor," she said quickly.

"I just want to be sure you have the correct address. Could you repeat it for me, please?"

"Just a minute," she said in an annoyed tone. Then, a moment later, "Here it is. Thirteen Hundred Marin Hill Drive?"

"That's it, thanks," McGuffin said, dropping the receiver on the hook and lunging for the car.

He drove through the center of Sausalito, past the No-Name Bar where he had first met his wife, then back out onto 101 and toward San Rafael. Even though it had been more than a dozen years (he had forgotten the exact date of their marriage), he remembered that first meeting as if it had happened only the night before. And he always would. For despite the grief she had caused him over the years, Marilyn was an unforgettable woman.

She had been standing at the bar dressed all in black, with fiery blond hair down to her waist, surrounded by a

group of admiring men. McGuffin had just returned from a weekend of skiing with his then girlfriend, a Sausalito schoolteacher, with whom he thought he might be in love. Until he saw Marilyn. And she saw him. She watched, with eyes that reminded him now of the moon behind the fog, glistening and elusive, as he steered the schoolteacher through the crowd to a table. He sat the teacher with her back to the blonde, then took the opposite chair. She stared at him with a bemused smile and McGuffin stared back, remembering, with ever-diminishing frequency, to shift his attention to the teacher from time to time.

McGuffin wasn't pretty and he knew it—his detective face had already been mauled a bit—but women were attracted to him and he knew that, too. Nevertheless, he usually found it difficult to approach strange women—unless, of course, he had had a few drinks. Then he moved through the singles saloons with the aplomb of a bad nightclub comic, and bombed just as often. But some women, and this blonde was certainly one of them, released something in McGuffin, a chemical perhaps, that made him feel invincible, even without the aid of alcohol. Even if it meant wading through all the guys at the bar, McGuffin decided then and there that he would either have her or make a tremendous fool of himself. He didn't realize at the time that it was possible to do both.

His chance came a few minutes later when the blonde pushed away from her admirers and walked across the room to the jukebox, sinuous as a black panther. Mumbling an inane excuse, McGuffin got to his feet and followed the blonde to the glowing pulsing jukebox where she stood studying the selections. She trailed her finger over the glass and didn't look up when the man in the ski sweater stepped beside her, brushing his hip lightly against hers.

"I'm going to take her home and I'll be back here in half an hour," McGuffin said. "Where will you be?"

"Right here," the blonde answered, without looking up from the musical selections.

McGuffin returned and one month later they were married. Those first couple of years with Marilyn were, McGuffin realized sadly, the best of his life. After she had decided to give up painting they moved back to San Francisco, where Marilyn bounced between the arts like a falling pinball. One year she was a poet, the next a singer, but never without some minor successes. Between careers Hillary was born and suddenly their marriage was good again. They would lie in bed for hours on Sunday morning playing with the baby and know that it was as much as life had to offer. Until Marilyn began to have her doubts. She went back to singing with a lousy rock group called Stump, then took up with cocaine and the lead singer, although McGuffin could never be sure of the order.

He was uncertain about a lot of things during that time. He decided to beat up his wife's lover, then decided that would be foolish—but at the last minute changed his mind again. He managed to avoid a criminal charge, thanks to a good but expensive lawyer, but was not so successful in the civil matter. It took most of what little cash McGuffin had left after the divorce to settle the matter out of court. She had shown him more misery and happiness than he had ever dreamed one woman capable, but she had also given him Hillary and that made it all worthwhile.

McGuffin reached into the glove compartment for his gun and placed it on the seat beside him. If anything happened to his daughter, he would surely kill somebody, he knew. But he didn't know if it would be Kruger or himself.

Just past the San Rafael exit, McGuffin pulled into a clean, well-lighted service station for directions to Marin Hill Drive. The attendant had never heard of it, but McGuffin found it on the map tacked to the wall, a twisting road on the ocean side of the San Rafael hills. He got back into the car and continued west, drove through the

town and then slanted north in the direction of Marin Hill Drive. He found it exactly where the map indicated it would be, a thin strip of potted blacktop that snaked up the side of a steep hill beneath a column of large eucalyptus trees. McGuffin dropped the car into second gear and began the slow winding ascent. There were small groups of mailboxes posted at intervals along the steep road and driveways leading either up or down to faintly lighted houses deep in the trees. He was sure he had never been here before, yet he experienced a quick *déjà vu* sensation of having driven this road once before. This was followed, without any apparent connection, by a sudden image of Miles Dwindling sitting with his black-leather doctor's bag, the magical mystery bag, clutched tightly in his lap.

McGuffin had been curious when he first saw the bag in the corner of the office, but Miles had been unwilling to satisfy his curiosity. "After you've been around awhile longer," the old detective had promised. It was only after Miles's death, when McGuffin as the court-appointed executor of his estate went through his things, that he was able to understand the old man's unwillingness to share fully with him the sordid realities of the detection business. The black bag contained electronic listening devices, infrared lenses, falsified credentials, a disguise kit, a stethoscope, a glass cutter and other cruder burglary tools. It was only then that McGuffin fully understood Miles's frequent assertion that he was a "licensed pragmatist." And it was only then that he realized why Miles had chosen a recent college graduate over several more experienced applicants for the job. Miles wasn't looking for police experience, he was looking for a fellow pragmatist.

After eighteen years in the business, McGuffin could understand this. He was often tempted to break the law in order to ensure justice for a client, and often did. But it was not a responsibility to be delegated to just anyone. Until now McGuffin, the intended lawyer, had assumed that his accidental profession was solely the result of Miles

Dwindling's untimely death. Faced with a file of open cases, he had consented to the probate court's request that he wind up Miles's business, a task, he estimated, that should take no more than a few weeks. But when a particularly interesting case showed up, McGuffin couldn't resist adding a new file to the drawer. Then another and another, until here he was eighteen years later, chasing after the man who had murdered his boss and started it all. Now, however, he wondered if pride might have had something to do with his decision to remain in the business. Being appointed heir to the pragmatist was a heady experience for a man so young.

McGuffin had no trouble finding Klaus Vandenhof's old Victorian house at the top of the hill. There was an ambulance parked in the front yard with a revolving red light on its roof. He lurched to a halt on the lawn beside the ambulance, slipped the gun into his jacket pocket and stepped out of the car. Seeing no garage or outbuildings where Marilyn and Hillary might be, he walked directly to the open front door, through which two sheepish ambulance attendants were beating a hasty retreat. A fat bald man in a red silk robe followed as far as the porch stairs.

"I want to know who made this report, do you hear me?" he shouted in lightly accented English. "And when I know I am going to sue everybody!" When the ambulance attendants boarded their vehicle, he turned angrily on the remaining stranger at the foot of the stairs. "Who are you?" he demanded.

McGuffin looked up at the old man glaring at him from the porch. He could easily imagine him forty years before, in jackboots and riding breeches, with short cropped hair, shouting angrily at French civilians. Now the thick muscles had given way to rolls of fat, beginning just below his shiny skull and continuing all the way to his ankles. He had added a lot of pounds, a lot of years and suffered a humiliating defeat, but the arrogance of the conquering soldier was still intact.

"My name is Amos McGuffin," he answered, staring intently at the fat man's eyes for a sign of recognition.

"So—? What have you to do with this suicide business?" he demanded.

Seeing that his name meant nothing, McGuffin shifted roles. "I'm here to straighten things out, Mr. Vandenhof."

"Straighten things out! You think you can straighten things out, just like that?" he asked, snapping his fat pink fingers. "Your men pound on our door in the middle of the night and when I open it they grab me by the throat and shout, 'What did you take, what did you take?' I thought they were accusing me of shoplifting!"

"I'm sorry if you and your wife were frightened—"

"Wife! What wife? I have no wife!" the fat man spluttered.

"I thought you said *our* door."

"I was speaking of my friend Toby, not my wife."

"I see," McGuffin said. "Is there anyone else in the house—besides you and Toby?"

"No, there is no one else in the house. And what difference would that make anyway?" he demanded. "Toby is very emotional. He is quite upset by this whole thing."

"That's too bad for Toby," McGuffin said, climbing the stairs to the porch.

"Where do you think you're going?" Vandenhof demanded, stepping in front of the detective.

"I'm looking for a woman and a young girl," McGuffin said, sliding his hand into his jacket pocket.

"A woman and a— Are you crazy?" Vandenhof said, placing a hand on McGuffin's chest.

McGuffin pushed the hand aside. "And a man named Otto Kruger."

"Otto—?" he asked, eyes opening wide. "Who are you?"

"I'm a private investigator. Your old friend has abducted my ex-wife and daughter and I'm going to find

them, even if it means tearing your house apart," McGuffin said, sliding the gun from his pocket.

The fat man's wide eyes tracked slowly to the gun, then back to McGuffin's face. "You—you are the young man who apprehended Otto—the partner of the man he killed."

McGuffin nodded. "I was young *then*. Now I'm older and a bit more irritable. Especially when somebody runs off with my daughter. But I'm sure you understand that, and I'm sure you won't do anything to make me angrier."

"I understand perfectly, sir. You have the gun, after all," he said.

"That's right, I've got the gun and I'm going to search your house," McGuffin said, motioning toward the door with the automatic. "So let's go inside."

"You know, of course, that armed burglary is a serious crime," the fat man warned, puffing himself up and out even further.

"So is mayhem," McGuffin answered, pushing the gun firmly against soft flesh. "But that won't keep me from shooting your kneecap off if you don't start walking."

The fat man shrugged and turned slowly. "Very well, sir. You have the gun," he said again. His slippered feet shook the porch as he walked heavily to the door.

McGuffin followed him into a dimly lit Victorian anteroom with a curved staircase to the left. When the fat man stopped and looked over his shoulder, McGuffin nudged him with the muzzle of the gun. "Keep walking," he ordered.

"You have the gun," Vandenhof replied, stepping forward.

"So you keep saying," McGuffin observed. "Where's your friend, what's his name?"

"Right behind you," a voice replied, as a cold steel gun barrel come to rest against the base of McGuffin's skull.

McGuffin froze as the fat man turned and, smiling, took the gun from his hand.

"Very good, Toby," he said. "Please raise your hands, Mr. McGuffin."

"Shit—" McGuffin muttered, lazily lifting his hands. He had stupidly allowed Vandenhof to stall him on the porch, while loudly warning Toby several times that he had a gun.

"Now put your hands against the staircase and spread your legs," the fat man ordered.

McGuffin grasped the spindles of the curved staircase and spread his feet as Toby patted him down one side and up the other. "I think I'm falling in love," McGuffin said, as Toby's hand went into his pocket. He came out with a handful of paper which he handed to Vandenhof, followed by his wallet.

"We will go into the library," Vandenhof said. "And please, no more jokes, Mr. McGuffin," he added, as Toby prodded him forward with the gun barrel. "I am not amused when a man sends an ambulance to my house and then forces his way in with a gun."

Toby steered McGuffin down the center hall and through a pair of sliding doors into the library at the rear of the house. Someone, Vandenhof or Toby, switched on a heavy metal chandelier that gave off a dim yellow light. The room had the look of a museum storage room, crammed as it was with obviously expensive antique furniture, dark paintings and odd bric-a-brac. A lead-gray suit of armor stood beside a massive carved chair with lion-head arms at one end of the room. The opposite wall was entirely occupied by a great stone fireplace beneath a large heraldic shield, a mantle of beer steins and a pair of crossed sabers. The center of the room was dominated by an enormous carved wooden table with another lion chair at either end. A full-sized statue of a nude Greek boy with minutely detailed genitalia rested on the center of the table.

"Sit there," Vandenhof ordered, pointing to the lion chair at one end of the table.

Feeling a push from Toby, McGuffin pulled the chair back and sat. He had his first look at Toby when he

moved out from behind him and stood beside the naked Greek. He could have posed for the statue about ten years before. Now, however, it wasn't a discus Toby was holding in his hand, but a World War II Luger, probably Captain Vandenhof's old service weapon. Vandenhof, however, had no need for it. He had McGuffin's Smith & Wesson 9mm automatic resting securely in his left hand, his wallet and papers in the right.

McGuffin studied the young man while Vandenhof went through his things. He was small and compact with a soft face and owlish brown eyes. He looked to be about thirty-five, but he was probably older. He had the kind of boyish features that would hold at that age for a long time. Vandenhof, too, who had to be at least in his mid-sixties, looked much younger than that in spite of the great slabs of fat that hung from his frame. He seemed to have been troweled together from smooth pink clay, then baked in an oven until he glowed.

"Why do you carry this?" the fat man demanded, flashing the yellowed newspaper clipping at him like a winning card.

"Your friend left it in my ex-wife's apartment," McGuffin answered.

"I don't understand—why should he do this?" Vandenhof asked.

"Because he's nuts," McGuffin replied. "And the first thing he did when he got out of the nut house was come looking for me. But he didn't find me so he took my ex-wife and daughter instead and left that clipping just so I'd know who had done it."

A smile came over Vandenhof's face as he studied the clipping. "How very much like Otto—always fond of metaphor. Did you know he was in the signal corps during the war?" he asked, looking up at the detective. "Until I plucked him out and made him my adjutant."

"No, I didn't know that," McGuffin answered. "And I don't particularly care. All I want to know is where he's

keeping my daughter!" McGuffin said, rising angrily from the chair.

"Sit!" Vandenhof ordered.

McGuffin saw the gun coming and ducked behind a raised arm, catching the brunt of the blow on his left shoulder, before clamping a hand tightly on the gunman's wrist and yanking hard. Toby hit the table face first with a sickening grunt that sent the gun sliding down the table like a well-struck hockey puck, until the fat man made the save.

"That will be enough!" the old soldier commanded.

Slowly, McGuffin lowered his hand, poised for a rabbit punch, to the table, as Toby, breathing hoarsely through a bloody nose, flopped about on the table, helpless as a fish.

"Help him up," Vandenhof ordered.

Delicately McGuffin lifted him by the collar. Two unfocused eyes danced above a red stream.

"Are you all right, Toby?" the fat man inquired.

"Awl kiwl him!" Toby blurted, spewing a fine red spray in the air.

"You'll do nothing of the kind," Vandenhof said. "You'll go upstairs and clean up that nose, then you'll take your medicine and go to bed."

"You're going to talk about Otto," Toby said, dabbing at his nose with a lapel of his blood-stained robe.

"It's just business, Toby, just business," the fat man said in a soothing voice. "Now go to your room and lie down. I'll be up just as soon as I've finished with Mr. McGuffin."

"If you don't finish him I will," Toby promised. Then he stuck his bloody nose in the air, pulled his robe tightly around his narrow hips and made a dignified if fey exit.

"An excitable boy," Vandenhof said, after he had gone.

"Excitable—?" McGuffin repeated. "That kid's about as stable as the San Andreas fault."

"And hopelessly jealous, I'm afraid. The mention of Otto, or any of my old friends, for that matter, always sets him off."

"I'll remember that."

"So," he said, placing the Luger on the table beside McGuffin's automatic, "you claim Otto has abducted your wife and child?"

"It's no claim," McGuffin replied. "He's got them."

"And this newspaper clipping is all you have? No ransom note, no phone call—?"

"That's the only communication I've had," McGuffin answered. "That's why I came here. I thought you might know where he is."

"And how did you find me?" Vandenhof asked.

"I found your name in the newspaper account of the trial. I phoned information and found you were still living in Marin County, but they wouldn't tell me where."

"So you claimed a medical emergency, then followed the ambulance to my house—?"

"That's right."

He stared at McGuffin and nodded slowly. "I assure you, Mr. McGuffin, I have no idea where your wife and child are being held." Then, satisfied that the detective believed him, the old man walked the length of the table and placed McGuffin's things on the table in front of him. McGuffin picked the gun up thanklessly and slid it into his jacket pocket as Vandenhof walked back across the room, this time to a cherry-red cabinet, the kind Marlene Dietrich should be draped over. "Would you like a drink?" he asked.

"No thanks."

Vandenhof opened the doors, revealing rows of gleaming crystal and dark bottles of foreign spirits. "A little schnapps clears the head," he said, selecting a bottle and a small snifter. He poured a little into the snifter, then replaced the bottle and turned to McGuffin. "You're sure?" he asked, raising the glass.

McGuffin shook his head. "All I want is Otto."

Vandenhof finished the drink in a single gulp, then smacked his thick lips. "That is something we both want," he said, reaching again for the bottle.

"You?" McGuffin asked.

"Very much," he answered, carefully measuring out another drink.

"Why?"

"Because he has stolen something of mine."

"What?"

Vandenhof replaced the bottle in the cabinet, then walked slowly to the table. He stopped at the chair to McGuffin's right and stared questioningly at the detective. "Have you ever heard of Peter Carl Fabergé?" he asked.

"Is he a friend of Kruger's?"

The fat man's chortle sounded like an idling marine engine. "Hardly that, Mr. McGuffin. Hardly that. Peter Carl Fabergé was the greatest goldsmith and jeweler the world has ever known. His most famous creations are the imperial Russian Easter eggs."

"Oh, yeah," McGuffin remembered. "Those hollow eggs with the picture of the czar's family inside—?"

The fat man laughed again. "Most amusing. Most amusing indeed. Fabergé made almost sixty eggs and I daresay not even the earliest were so primitive as that. The first one was given by Alexander III to the czarina in 1884. It was made of gold and enameled opaque white. And when the czarina opened the shell, she discovered a golden yolk. And when she opened the yolk she discovered a tiny perfect chicken made of varying shades of gold. And inside the chicken she discovered a perfect model of the imperial crown. And inside this, inside this, sir, hung a perfect ruby egg," he said, holding his clenched fingertips aloft.

"Which came first?" McGuffin asked.

"Have your little joke," the fat man said. "Admittedly the eggs are a symbol of decadence to some. I, however, prefer to view them in their broadest symbolical sense. Since the dawn of civilization the egg has been looked upon as the symbol of the origin of all things. Did you know that the ancient Persians painted and ate eggs at the

spring equinox, hundreds of years before the birth of Christ?"

"I didn't know that," McGuffin admitted.

"And the Greeks worshiped the egg of Orpheus. And the Hindus worshiped the Golden Egg of Brahma. And the—"

"And the leg bone's connected to the hip bone," McGuffin interrupted. "Get to the point."

"The point is, Mr. McGuffin, that the egg is the most perfect of earthly forms, and Peter Carl Fabergé has made it heavenly. And if you could only see one of them, you would not be so impatient to get on with your mundane business. Why, do you know," the fat man said, eyes dancing with excitement, "that one of them actually contains a tiny elevator?"

"No, I didn't know that either," McGuffin admitted.

"Yes! And when the top is opened, a statue of Peter the Great astride a golden horse mounted on a sapphire pedestal rises from the egg. Each egg is unique and one is more beautiful than the next. Some are set with diamonds and pearls and rubies and sapphires, and laced with silver and platinum," he went on with almost orgasmic enthusiasm.

"But the most beautiful egg, Mr. McGuffin, the most ingenious and exquisite of them all, is the one given by Nicholas II to the Czarina Alexandra Feodorovna to celebrate the tercentenary of Romanoff rule in 1913," he said, his narrowed eyes gleaming like tiny jeweled eggs as he pressed his face close to the detective's.

"The one Kruger stole from you?" McGuffin asked, leaning away.

"The same," Vandenhof said, straightening up. "The workmanship is beyond imagining and the jewels were the finest to be had at the time. On the outside are miniatures of all the Romanoff czars, framed by Russian eagles in chased gold on white enamel. The pedestal is the Russian imperial shield in porphyry, set with precious stones and gold. And inside the egg is a globe with two maps of

the Russian empire inset in gold, one of the year 1613, the other of the year 1913."

"How much is this thing worth?" McGuffin interrupted.

Vandenhof shrugged. "Broken down, perhaps a million dollars or so. But that doesn't interest me."

"You mean it's hot," McGuffin said. "You stole it and you can't get rid of it."

"I have no wish to get rid of it, Mr. McGuffin," the fat man replied firmly. "I only wish to reacquire it. And, as to my right of ownership—the egg disappeared from the palace following the overthrow of the czar, then showed up in Paris some twenty-five years later. In view of these gaps in the chain of title, I should say that in this case, possession is ten-tenths of the law."

"How did you get possession?" McGuffin asked.

"With all due respect, sir, that is none of your business. As you yourself said, your only business is finding your daughter. And to that end I am willing to make you a most generous offer. I am willing to lead you to Otto Kruger, but in return you must do something for me."

"You want me to bring you the egg."

"A fair exchange, I should say."

"Fair enough," McGuffin allowed. "But what makes you so sure I'll keep my part of the bargain once you've led me to Otto and I have my daughter? I might just forget about the egg, or worse yet, decide to keep it for myself."

"That's precisely the reason I've never hired anyone in the past to go after the egg for me. Who could one possibly trust to return an object of such value? But my intuition tells me that you, Mr. McGuffin, are an honest man. I have to believe that providence directed you here to me tonight."

"I'm flattered," McGuffin said.

"I also believe that your daughter means more to you than all the money in the world. But, of course, once your daughter is out of harm's way, money may again assume

its usual importance to you. Therefore, if you betray me, Mr. McGuffin, I will be forced to send Toby to kill your daughter. I'm sure you understand."

"Oh, sure, no hard feelings," McGuffin replied. "What I can't understand is why you don't just send Toby after the egg."

The fat man smiled ruefully and shook his head. "Otto stole my egg only to cause me pain. He knows it's the thing I love more than anything else in the world, and being without it is the most fiendish torture he can inflict upon me. He would force Toby to kill him before he would see me have it."

"It sounds as if your divorce was as bad as mine," McGuffin said.

"Find my egg, Mr. McGuffin. Find it and I'll pay you a handsome bonus."

"How much?"

"Ten thousand dollars."

"Ten thousand!" McGuffin wailed. "For an egg that's worth at least a million broken up?"

"But I don't intend to break it up," Vandenhof replied. "I'm offering you ten thousand dollars for the return of a keepsake whose only value is one of sentiment."

"And what makes you think Otto feels the same way about it?" McGuffin asked, pushing his chair back and getting to his feet. "What makes you think he hasn't already broken the egg and sold off the stones?"

"I know he hasn't because I know Otto," Vandenhof replied easily. "As long as he has the egg in its original state, he has the power to hurt me. But once it no longer exists, he no longer has that power. No, Mr. McGuffin. Otto wouldn't dare destroy the egg."

"You make it sound as if this egg is cursed," McGuffin said.

"Not cursed, Mr. McGuffin, blessed," the fat man replied. "And once you lay eyes on it, you, too, will come under its magical spell. What do you say? Do we have a deal?"

McGuffin hung his hand on the back of his neck and stared at the floor. "Yeah, we got a deal," he said, looking up from the floor.

"Congratulations!" Vandenhof exclaimed, then bolted his schnapps down in one gulp.

"But I have to have an advance," McGuffin added.

"How much?" the fat man asked guardedly.

"Half now, half when I deliver the egg."

"Ten percent now, the rest when you deliver the egg," Vandenhof countered.

"Cash?"

"If you prefer."

"I prefer."

"Very good," Vandenhof said. He placed his empty glass on the table and walked to the fireplace at the end of the room, the silk robe billowing behind. He rolled the heraldic shield easily to one side, revealing a wall safe that he opened quickly, then reached inside for a handful of bills. He counted off ten bills and returned the rest to the safe and closed the door, but not before McGuffin had had a glimpse of the contents of the safe. Behind the stacks of banded currency was a solid wall of gold ingots. The refugee from war-torn Germany had done very well for himself in the New World—or the Old.

"Now I understand why you keep a gun in the house," McGuffin said, as Vandenhof rolled the shield back in place.

"We keep a great many more than one in the house," Vandenhof replied as he approached the detective, his fee in hand. "As well as an extremely sophisticated alarm system."

"The antiques business must have been very good to you."

"I won't deny that," he said, stopping just out of McGuffin's reach. He held the bills close to his chest. "I'm afraid there is still one troubling aspect of our agreement that remains to be worked out, no matter how disagreeable it might be to both of us."

"What's that?"

"As you well know, Otto is not emotionally stable."

"You seem to have a weakness for that kind of man," McGuffin said, with an upward glance.

"It does add spice," he said, grinning like a fat fox. "The point is, however, that our agreement is not contingent upon the welfare of your ex-wife and daughter. Once I lead you to Otto, you are duty bound to return the egg to me, no matter what you might find when you get there. Are we agreed on that point?"

"Okay," McGuffin said, nodding slowly. "But there's something you have to understand, too."

"Yes—?"

"My daughter comes first, not the egg. If anything happens to her because of your carelessness or greed, the only use you'll have for your precious egg is as an urn to hold your ashes."

His eyes returned McGuffin's fierce stare, then all but disappeared in crinkled flesh as a soft chuckle built from his bowels to a wheezing laugh. "By God, sir, I think you would, too," he said finally. "I can see you're crazy about that little girl. As crazy as Otto and Toby," he added, followed by a final roll of laughter. "It would seem, sir, that we are both about to embark on a most dangerous enterprise."

"It adds spice," McGuffin said, taking the bills from Vandenhof's hand. He slipped them into his pocket, next to the gun, without counting them.

"You are a find, Mr. McGuffin. You are a find indeed. I think we may be able to do some business in the future. Assuming I have a future," he added with a laugh.

"How do we go about finding him?" McGuffin interrupted.

"We," he said pointedly, "will do nothing. I, on the other hand, will contact certain members of our community and ascertain the whereabouts of Otto. When I've learned this, I'll be in touch with you."

"How long will that take?"

"Not long. Our community is a small one."

"The gay community is small?" McGuffin asked, incredulous.

"Gay German war veterans," Vandenhof qualified.

"Gay German war veterans—?" McGuffin repeated. "You people really are organized, aren't you."

Vandenhof smiled, laid a hand on McGuffin's shoulders and led him to the door. "Don't worry, Mr. McGuffin, you will soon have your daughter back. And I will have my egg."

"If Otto's got your egg, I'll get it," McGuffin assured him as they walked to the front door. "And when I do, how do I get in touch with you?"

Vandenhof gave him his number and McGuffin handed him his card. Toby was lurking halfway up the stairs like a scolded child, glaring malevolently at him, McGuffin saw, when they halted in the doorway.

Vandenhof looked up from the card with a puzzled expression. "What is this—*Oakland Queen?*"

"I live on a ferry boat," McGuffin answered.

Vandenhof smiled. "How very nice for you," he said, reaching for McGuffin's hand.

McGuffin shook hands and said good-bye, then walked down the stairs to his car. During the drive down the hill in the dark, he again had the strange feeling that he had been there once before.

When McGuffin returned to the *Oakland Queen* a little less than an hour later, he found an envelope taped to the wheelhouse door. Certain that it was the ransom note, he tore it from the door and clumsily ripped it open.

"Shit," he muttered, seeing it was not from Otto Kruger, but from his landlord.

Dear Mr. McGuffin,

You will recall that as a condition of free domicile aboard the O.Q., you agreed to perform certain minimal security duties, which, due to your recent Carib-

bean sojourn, has resulted in yet another office bur-
glary aboard the Queen.

Seeing as how I've had more burglaries with a
security guard than without, I thought that at the very
least, the matter deserved some polite discussion, which
I attempted earlier this evening, only to be violently
attacked and knocked to the deck, resulting in a severely
sprained back.

You will kindly therefore pack your bags and be off
my ship by the end of the week, or face civil and crimi-
nal prosecution to the fullest extent of the law.

Sincerely,
Elmo Bellini

McGuffin crumpled the note and let it fall to the
deck, then opened the door and stepped into the wheel-
house. He would deal with Elmo later, just as he had,
successfully, so many times before. Or, was that the push
that had at last broken the landlord's back, McGuffin
wondered, as he pulled off his jacket. Eviction from home
and office was a serious matter, but he couldn't afford to
think about anything now except his daughter's welfare.
And Marilyn's.

She had put him through a lot during their marriage,
but now the rancor was gone, replaced by a fondness that
was in some ways more comfortable than love had been.
A taste of the single life, it seemed, had changed Marilyn
for the better. She was more relaxed, not so full of con-
flicting ambitions as she was when they were first mar-
ried, ready now to be a wife and mother. At their last
meeting, McGuffin had the impression that she was ready
to give their marriage another try—although she would
never be the one to propose it. And that's where it stands,
McGuffin thought, kicking off his shoes and letting his
pants fall to the floor.

Down to his shorts, he walked into the tiny bathroom
and splashed water on his face. This wasn't his first miss-
ing child case—he had tracked down more than a few

43

kids who had been taken by one disgruntled parent or the other—but it was the first time the object of the search was both daughter and client to the detective. It was, he knew, the kind of case that should be referred to an objective, third-party detective. But he didn't have that luxury. There was no one he could trust. Not the police, not the FBI. Otto Kruger was a German land mine who could go off at the slightest tremor and McGuffin, despite his personal stake, was the only demolition expert available. Stay calm, get a good night's sleep and wake up with a clear head, he told himself, as he slid into bed.

But sleep wouldn't come. He lay stiff as the mattress on his narrow cot and listened to the foghorns on the bay, while the worst possible scenarios played over and over in his brain. He thought of getting up for a drink, just to calm his nerves and put him to sleep so he'd be fresh in the morning, but managed to disabuse himself of that rationalization. There was nothing to do but ride it out, count the foghorns, try to think of something pleasant. Like pushing Hillary on the swing in the park at the foot of Telegraph Hill when she was three or four, and filled with an unendable source of unanswerable questions. The few answerable ones all seemed concerned with death or sex and required evasive answers anyway. He couldn't remember the questions. He remembered pudgy legs and white socks and little red sneakers, and the way she turned her head, jerkily, like a pigeon, and looked up to him for everything. But everything could never be enough.

Now he saw her swinging again, the timid smile changing to fear as she climbed higher and higher with each shove, higher than the bar, until the chain went slack and snapped her with a jolt. She began to cry, then scream as the swing twisted from side to side, soaring high above the bar, then plummeting each time to a cruel jolt before beginning again. McGuffin tried to stop the swing, then realized he was not pushing. He was looking on from another place, unable to get to her as she twisted

and turned, pushed by an invisible hand, or the devil himself. Then he saw—it was Otto Kruger, dancing and laughing as he pushed Hillary higher and higher into the air, until it seemed the chains would snap and she would hurtle into the sky.

At the sound of the phone, McGuffin bolted upright, damp with sweat, and fumbled for the receiver.

"Good afternoon, sir," a voice greeted.

"Afternoon—?" The dark sky and lead-gray rain knocking against the glass insisted otherwise.

"I trust you have had a restful night after our little talk," Klaus Vandenhof said.

McGuffin's head cleared in an instant. "Did you find him?"

"I did, sir," the old soldier replied smartly. "It seems he has taken refuge with an old comrade in the hills of the wine country near—"

"Is my daughter there?"

"This I was unable to determine," Vandenhof replied. "But I should say it's a good bet. My informant tells me that Otto has made several mysterious trips to and from the vineyard since arriving there directly after his discharge from hospital."

"Which vineyard?" McGuffin asked, reaching for pen and paper.

"The Hans Hauptmann Vineyard near St. Helena. Hans and Otto are old friends. Apparently the doctors were not entirely convinced that Otto was completely stable, but they decided eventually to release him in Hauptmann's custody because they thought he was too old to harm anyone."

"He must have lied about his age," McGuffin mumbled as he wrote. "Do you know this guy—Hans Hauptmann?"

"I know him, but that is all," Vandenhof answered coolly.

"It doesn't sound as if you're friendly."

"Let us say his wine is too sweet for my taste."

"Let us say a little more than that," McGuffin countered. "If I'm going to bust into Hauptmann's vineyard, I want to know what kind of people are going to be guarding the gate."

"Efficient," he answered, after a short pause.

"I might have known—how do I get there?"

Vandenhof recited directions while McGuffin scribbled. "You do remember our agreement, do you not?" he asked, when he had finished. "No matter what state you find your daughter in, you will still return my egg."

McGuffin dropped his pencil and inquired in an even voice, "Do you know something you're not telling me?"

"I've told you all I know," Vandenhof assured him. "I just want to be sure you don't forget our deal."

"And I just want to be sure you don't forget my promise."

Vandenhof's wheezy laugh faded and disappeared as McGuffin replaced the phone.

2

The road to Napa is paved with good temptations.

Markers of the great California vineyards line the highway that twists through the vine-covered hills, urging the traveler to stop and sample the grape in the cavernous tasting rooms at the foot of the terraced slopes. And to accompany the wine, restaurants, inns, cheese factories, bakeries and other provisioners of foodstuffs occupy every quaint old building along the Silverado Trail, as well as some not so old. Most of the restaurants serve mediocre food—in the summer when millions of voracious tourists invade the valley there's little time or reason for anything better—but there are a few inns that serve decent meals.

McGuffin knew where most of them were located, but today, he thought, as he pushed the old coupé through a twisting turn, I'll be stopping at none of them. When he confronted Otto Kruger and his Nazi winemakers, he would be lean as the hunter and quick as the cat. He tried

not to think of the great wines that rested in the cool aging cellars and distracted himself instead with the zany estate houses that poked occasionally through the grapes, like ragged chunks of cork floating in a glass. One resembled a Spanish mission, one a Greek villa, one a Victorian ginger-bread and another a Gothic pile. One looked as if it might have been moved, marble block by marble block, from the hills of Sicily, while another looked as if it had been plucked from beside the Loire and placed at the crest of the Napa range. Most of the traditional European houses were built in the nineteenth century by French, German and Italian immigrants who, with little idea of the soil or climate that awaited them, nevertheless nurtured and carried their vines by ship and wagon, all the way from their homeland to California. Did they envision a wine industry? McGuffin wondered. Or did they just want to make sure they had something to drink with dinner? Probably the latter, be-cause almost all of the original families were now out of the business, victims of earthquakes, Prohibition, gentleman vinters or corporate acquisition.

McGuffin slowed at the town limits and drove carefully down the main street of St. Helena, the 1890s museum-piece town that was the center of wine country. The gray rain still pelting San Francisco was but a distant memory in this leafy, sunny place. Like the random architecture that dotted the green hills, St. Helena looked as if it, too, had been torn whole from another place and planted in the center of this California valley. The shops and taverns and frame houses that lined the main street made McGuffin think of a prim New England village, the way Walt Disney would have done it. If I lived in a town like this, I'd always be afraid of breaking something, McGuffin thought, as he watched it recede in the rearview mirror. But given the choice of the wine town or Calistoga, the next town up the road, where the health nuts came to take the waters, he'd take the wine town every time.

The road to the vineyard, just past the Old Bale Mill, was marked by a peeling sign—HANS HAUPTMANN VINE-

YARDS, NO VISITORS. *Achtung!* McGuffin said to himself, as he glided past the gravel road that zigzagged up the side of the vine-covered hill. The large stone house and barn at the crest of the hill were all but obscured by a lonely stand of tall eucalyptus trees. Around the turn and out of sight of the house, McGuffin pulled the car off the road and stopped. He reached into the pocket of his brown tweed jacket for a spiral notebook, flipped to a clean page and printed in block letters: DISABLED CAR. GONE TO HAUPTMANN VINE-YARD FOR HELP. If I don't come back, the cops will at least know where to come looking for me, he thought, as he tore the page from the book and placed it under the windshield. Then he reached under the seat and came up with his Smith & Wesson 9mm automatic, which he slipped into his jacket pocket as he slid out of the car. He walked quickly across the roadside clearing and was swallowed up in an instant between two rows of thick, grape-heavy vines.

Although the grapes were not yet ready to be harvested, they gave off a sweet smell in the hot sun as McGuffin made his way stealthily up the side of the furrowed hill. By the time he reached the first terrace, less than halfway up the steep hill, his back was damp with sweat. He wanted to remove his tweed jacket but didn't, knowing that his white shirt might be seen through the foliage, even though the house was still several hundred yards above and to the right. When he saw a wagon perched on the ledge directly beneath the house, he struck out diagonally across the grain of the vineyard, ducking under the wire strung from post to post. He was now dripping wet and his shoes and pants legs were covered with clay dust by the time he reached the point that he estimated to be directly below the house. He changed his course to straight up the hill, until he was stopped by a dirt embankment some five or six feet high.

When McGuffin peered over the top of the embankment and through the spoke wheels of the wooden cart at rest on the dirt road, he saw a young man digging at the vines across the road. And beside the young man, ears

pointed skyward, stood the largest German shepherd McGuffin had ever seen. He lowered himself and pressed against the embankment while he considered his next move. There would be no crossing here. Nor anywhere else, if that dog was part of a cadre of guard dogs and not just a single house pet. Getting past a human guard, even an efficient German, was always a possibility. But getting past a pack of junkyard dogs, and McGuffin had the scars to prove it, was as likely as running through the Chicago Bears.

Deciding to look for another place to cross, McGuffin got to his feet and, head down, began to run along the embankment. He had gone only a short distance when he stepped into a hole and sprawled face down on the grass, accompanied by a suppressed but painful grunt. Ignoring the pain in his leg, he pulled the gun from his pocket and rolled over on his back, expecting the German shepherd to leap off the embankment and eviscerate him at any moment. But no dog appeared, nor did any sound come from the terrace above. He waited for a minute, then climbed to his feet and gingerly tested his knee. It was tender but workable.

It was then that he saw what had tripped him—a recessed hatch cover, all but concealed by blown silt and sparse grass. An old well or cistern, McGuffin thought, until he remembered—! Some of the vineyards he had visited, Inglenook and Beringer among them, had subterranean storage tunnels carved deep into the rock, running for great distances under the vineyard. The entrance to the tunnel, if this were one, would logically be from one of the buildings above, the barn or the main house.

McGuffin slid the gun into his pocket and dropped down to examine the hatch cover, wincing but otherwise ignoring the pain in his knee. He dug the loose soil from around the edge of the wood, found a fingerhold and tugged. A cool rush of damp air blew up from the black hole as he lifted and slid the cover to one side. The low sun poked only several feet into the black before being

swallowed up. He dropped a clod of yellow clay into the hole, heard the soft, dry thud of exploding dirt, and estimated the drop to be about twenty feet, too far for a free fall into an unknown void.

The detective sat back on his haunches and pondered his problem. He could go back to town for a length of rope, or, he thought, surveying the long rows of vines strung from post to post on baling wire, make do with what's available.

He scrambled through the dry dust on hands and knees to the first post, then followed the wire hand over hand from post to post until he found its end. He unwound the wire from a rusty nail, then returned to the first post and began pulling the wire toward him, as one by one, each grape-laden plant fell softly to the ground. When some thirty feet of wire lay in a loose coil at his feet, he wrapped it twice more around the post and began feeding it into the hole. When it was all played out, he sat on the edge of the hole and prepared to lower himself, until it occurred to him that lowering one hundred and seventy-five pounds on a strand of wire could be harder on his hands than the worst dishwashing liquid. He moved the gun from his jacket to his pants pocket, then removed the jacket and wrapped it around the wire. Then he pushed off and slid to the floor of the cave faster than a probationary fireman. The bad knee complained, but he had survived, he realized, as he peered up at the circle of light, a much longer drop than he had anticipated. He felt around the floor, found his jacket and put it on, then moved forward slowly in the darkness until he found a stone wall.

Walking and feeling his way along the stone wall, his hand struck a cool metal pipe after some one hundred feet. It was an electric conduit, he realized, when he found the switch box at the end of it. When he flipped the switch, a sparse necklace of hooded bulbs flashed yellow cones of light down a long tunnel of oak casks. Once again McGuffin removed the gun from his pocket and limped cautiously in the direction of the last light at the end of the tunnel. Lesser

tunnels spoked off left and right, but he stayed to the main stem, until at the end he found himself in a large cave filled with racks of bottled wine. He walked across this room to a second tunnel and stairs, then climbed cautiously to the top, emerging finally in a cavernous barn crammed with grape-stained wagons, farm machinery and a black Mercedes. The barn door was partly open, revealing the house across the yard in the gathering dusk, a great stone jumble of turrets and spires.

McGuffin threaded his way between the wagons and stopped beside the open door. In the last light of day the house looked like a pumpkin-colored castle on the Rhine. There was a pickup and three cars parked at the side of the house, one of them a dark sedan—perhaps the one that had carried Marilyn and Hillary off. Someone was moving about in the kitchen. There were lights in a sec-ond-floor bedroom window and a lone light near the top of the round tower at the far corner of the building. Is that where they are, in the tower? McGuffin, no stranger to the ways of knights, ladies and evil dukes, wondered. And if so, what would Errol Flynn do about it? Climb up the tower and swing through the window?

Unromantic though it was, McGuffin decided to look for an unlocked door or window. He was about to make a run for the house, when suddenly a tennis ball bounced across the yard in front of him, followed quickly by the German shepherd. McGuffin stepped back quickly, then watched as the dog clamped his jaws on the ball and re-turned it to the thrower, the same young man he had observed in the vineyard a short while before. McGuffin backed around a grape wagon as the man and his dog approached. If he leaves that mutt outside, I've got a problem, McGuffin thought.

But the young man was not going to leave the dog outside, McGuffin realized, when, a moment later, the dog and his master appeared in the doorway. The dog trotted across the barn to its blanket and lay down with a

sigh, as its master rolled the door closed, leaving McGuffin and the dog in darkness.

"Oh, shit," McGuffin breathed softly.

But not softly enough. The growl was soft and throaty, not much louder than the purr of a cat, nor more frightening than the rattle of a diamondback. Foolish though it was—McGuffin could scarcely hit a stationary target in a lighted pistol range, let alone a charging dog in a dark barn—he removed the automatic from his pants pocket and switched the safety off, with a fairly audible sound that sounded to the dog like a dinner bell. McGuffin tossed the gun over the top of the wagon and, with an athleticism he thought long gone, followed it with a single bound, scarcely a second before the snarling dog landed on the vacated spot. While McGuffin scrabbled over the bottom of the wagon, searching desperately for the gun, the dog leaped repeatedly at the wagon, like a frenzied shark trying to board a lifeboat. When the dog managed to get his paws and head over the edge, McGuffin was forced to abandon the search and rush to the barricade. He removed his jacket, wrapped it around his fist and delivered a hard blow to the dog's nose that sent him yelping to the canvas. But like Schmeling, he kept coming back, toenails scratching furiously at the wooden sides of the wagon, until McGuffin managed to knock him off with a now tattered tweed jacket, before returning briefly to the hunt for his lost gun. The struggle came to an abrupt end when the door slid back and the dog handler stepped inside.

"Come down out of there!" he shouted over the barking dog.

"Not until you put that panzer on a leash!" McGuffin shouted back.

The handler called and the dog moved reluctantly to his side, not entirely satisfied that his master truly understood the danger.

"Now climb down!" the young man ordered. "And don't try anything or I'll turn the dog on you."

McGuffin climbed over the top of the wagon and jumped to the ground, wincing at the sensation in his tender knee. The dog growled a soft warning as his master came forward and took the shredded coat from McGuffin's hand. He went through the pockets, came away with McGuffin's wallet and then tossed the jacket back to him.

"Amos McGuffin, private investigator—?" he said dubiously, as he examined McGuffin's license. McGuffin nodded. "Let's go inside," he said, stepping aside to let McGuffin go first. "And don't forget about the dog."

"He's unforgettable," McGuffin said, stepping out of the barn.

He also remembered his gun, still in the wagon, as he walked across the yard, but knew this was not the time to bring it up. The kitchen door opened and two more men stepped out onto the small porch. One was short, with thinning white hair, the other tall, with flaxen blond hair.

"What is it?" the older one asked.

"Karl, go and get Otto," the dog handler said.

The younger man stepped into the kitchen and disappeared as McGuffin stepped up onto the porch. The old man regarded him with puzzled, watery blue eyes and asked again, "What is it, Hans?"

"Nothing, Dad," the young man replied, laying a hand on his shoulder. "Why don't you go upstairs and lie down?"

Reluctantly the old man stepped into the kitchen and walked slowly across the room to the stairs in the corner. When he started upstairs, the young man motioned McGuffin inside. The old man would be the vintner and the younger his son, Hans Hauptmann, Jr., McGuffin reasoned. It also seemed that he and the flaxen-haired one, Karl, were working for Otto Kruger.

It was only when McGuffin walked several steps into the kitchen that he noticed the impassive stout woman at the sink, doing something to a slab of raw meat.

"Stay here," Hans ordered, then walked into the next

54

room, leaving McGuffin with the stout woman and the dog.

She stared impassively at him while she continued to knead the beef, sending a trickle of blood over the sideboard and into the sink. The dog stood in the middle of the room, dividing his attention between his captive and the meat. When McGuffin smiled and nodded at the woman, she frowned and the dog growled. McGuffin wiped the smile from his mouth and stood motionless until, a few minutes later, Hans returned.

"Come," he ordered.

McGuffin and the dog, in that order, followed Hans through the door into a large dining room, then out and down a corridor to a smaller room at the front of the building. A small man stood in front of the casement window at the end of the shaded room, silhouetted by the last light of day. McGuffin knew, even before he switched on the green-shaded desk lamp, who he was. The pasty round face that had always resembled an unbaked pie was now even a bit whiter, setting off his dark pop eyes like a pair of eight balls.

"What have you done with my wife and daughter?" McGuffin demanded.

His eyes narrowed and his mouth fell open. "How—how dare you!" he gasped. "After vut you haf done to me—to come here, to trespass—to demand to, to—" His head shook and his hands waved, frustrated, unable to continue.

"What happened to you was your fault, not mine," McGuffin charged.

He clenched his hands into doughy little fists. "You had no business—!" he said, his voice a furious hiss.

"He was my partner. You killed him and I put you away and that's how it had to be. But if you've done anything to Marilyn or Hillary, you're gonna wish you were back in Napa, rather than here with me," McGuffin promised. When he raised a hand and pointed his finger at Kruger, the dog growled warningly from behind him. "And I'll

strangle your fuckin' dog, too," he added, fueled by frustration. "Where are they? I want 'em here right now or the whole fuckin' bunch of you are goin' away for a long time!"

The old man began to shake with anger. "You vuld threaten me?" he demanded, lunging across the desk, resting on his knuckles, looking eerily like a frog in the green light. "Vut do you think you haf—vut power? You are not in your courtroom now, Mr. McGuffin. You are in my courtroom. Do you understand?"

"I understand well enough that I didn't come here without protection, if that's what you mean."

Kruger's bug eyes went quickly to Hans, who shook his head and replied firmly, "There was no one with him." Kruger straightened up and smiled at his captive.

"I reported their abduction to the San Francisco Police Department and told them I was coming up here," McGuffin bluffed. "And if I don't leave here with my wife and daughter they're gonna bust this place wide open."

"And ven vill this take place?" Kruger asked, still smiling.

"Don't fuck with me," McGuffin warned. It sounded hollow even to him—and Hans's laugh only confirmed it.

"Sit down, Mr. McGuffin," Kruger ordered.

McGuffin felt a chair hit him in the back of the legs and he sat. The dog followed, uttering a bored sigh. Even he knows I'm a fake, McGuffin thought.

Kruger adjusted the lamp shade until the light shined directly in McGuffin's eyes, then he drew a long brown cigarette from a pack atop the desk. He lit the cigarette with a small silver lighter of the kind you don't see anymore, the expensive kind with wick, flint and fuel that gets lost instead of thrown away. Then he walked to the window and leaned one elbow against the casement. To McGuffin, almost blinded by the lamp, he was just a shadow marked by an occasional red glow.

"I heard a little vile ago that my old friend Klaus Vandenhof has suddenly taken an interest in me," came the voice from the shadow. "And now you. I am flattered

by all this attention, Mr. McGuffin, but I must know—vut compact haf you made vit Klaus?"

"He offered to help me find my wife and daughter, that's all," McGuffin answered.

"You are lying," Kruger responded softly. "Klaus vill do nothing for no one—least of all look for lost vives and kids—unless there is something in it for him. So tell me, Mr. McGuffin, vut is your business vit Klaus Vandenhof?" he asked, pushing away from the window.

"We have no business," McGuffin replied.

Kruger's face appeared suddenly above the lamp, looking this time like a green fish. "Vuld you like to see some dog tricks?" he asked.

McGuffin shook his head as Hans called from behind him, "Schatze!"

Schatze got up and trotted around in front of McGuffin. When Hans placed an open palm on his chest, Schatze crouched, bared her fangs and snarled softly at her seated quarry. McGuffin sat very still, poised to kick out should the dog attack, unsure what to do after that. How do you fight a German shepherd?

"Be very still," Kruger instructed softly. "At the slightest move, Schatze vill tear your throat out. And I vuld be perfectly vithin my rights. Because even if you came here looking for your vife and child, in the eyes of the law you are still a trespasser, Mr. McGuffin. You understand, yes? You may speak, but do not nod," he added quickly.

"I understand," McGuffin said, with a locked jaw that would be the envy of Locust Valley.

"Good. Now, ven Hans raises his hand to his throat, Schatze vill do the same to your throat, but vit her teeth. Unless you talk," he added with a quick smirk.

"I think I'd like to talk," McGuffin said finally.

"Vunderful," he said, with a nod to Hans.

Hans did something with his hand and Schatze slumped to the floor. She pressed her jaw against the rug and looked up at McGuffin with brown cow eyes, the whites showing beneath.

"Vixen," McGuffin said.

"Vell—?" Kruger asked, then waited.

"I'll tell you everything you want to know, but first I have to see my wife and daughter—I have to know they're all right."

"They are fine," Kruger said, shaking his head impatiently.

"Then let me see them."

"I cannot."

"Why not?"

"You don't think I vuld be so stupid as to bring them here, do you? Now if you expect to ever see them again, you vill stop stalling and answer my question. Vut is your business vit Klaus?"

When McGuffin hesitated, the dog looked at Hans, as if expecting to be called back to work. McGuffin took a moment to consider the options, then decided to bare his soul. "He wants me to get the egg."

"The egg—?"

"The Fabergé egg," McGuffin said. "The one you stole from him."

Otto Kruger's big round eyes seemed suddenly about to pop out of his head. "Klaus thinks I haf the egg—?"

"But just give me your hostages and I'll forget about—" McGuffin began, then stopped. "Don't you?"

Kruger collapsed slowly into his chair and stared dully at McGuffin for a moment. "All this time—," he said, then began to laugh, softly at first, then louder and louder, until McGuffin was sure he was reverting to madness. Tears ran down his cheeks as he struggled to speak. "All this time Klaus thought I had the egg—and all this time I thought he had it!" he exclaimed, followed by more laughter and tears. "This is very funny, Mr. McGuffin," he said, wiping his cheeks with the back of his hand. "And very tragic. If Klaus doesn't haf it, and I don't haf it, then who does haf it?"

McGuffin shook his head. "I don't know."

"What about you, Mr. McGuffin?"

"Me! If I had it, don't you think I'd offer to trade it for your hostages?"

Kruger studied him for a moment, then nodded. "Yes, I'm sure you vuld." He got to his feet and turned the light from McGuffin's eyes. "In vich case there is only one man who could haf it."

"Who's that?" McGuffin asked.

"Miles Dwindling," Kruger answered.

"Miles—?"

"Is dead, I know. I killed him," the madman admitted. "And do you know vy?" McGuffin shook his head. "Because he stole the egg from me."

"Bullshit," McGuffin replied. "Miles never stole anything from anybody. He was the most honest man I've ever known."

"Mr. Dwindling stole the Fabergé egg from Klaus," Kruger replied surely. "I know because I hired him to do it—after Klaus threw me out—"

"Of the house!" McGuffin exclaimed. Suddenly he knew the reason for his strange *déjà vu* experience while driving to Vandenhof's house. He had been there eighteen years before, only a short while after going to work for Miles. He remembered the white-haired detective sitting stiffly in the passenger's seat beside him, the black leather bag clutched in his lap, as McGuffin drove to Marin County in the middle of the night.

"A marital problem" was all Miles would say when his young assistant inquired as to the nature of the case. McGuffin remembered letting his boss out near the top of a hill, then waiting for nearly an hour until he returned, still clutching his magical mystery bag. He didn't know until he had gone through the bag, after Dwindling's murder, that it contained safecracking tools, among other things, nor did he know until now that it also contained the Fabergé egg.

"I offered Mr. Dwindling five thousand dollars to get the egg from Klaus's safe and he accepted my offer," Kruger went on. "But ven I vent to his office to collect it,

59

he told me he had changed his mind and returned the egg to Klaus. I believed him and so I killed him. I should haf known he vas lying!" he said, slamming his little fist on the desk. "Once he got a look at the egg and saw how much it vas vorth, he decided to keep it for himself."

It didn't seem possible. McGuffin had administered the estate—Miles had died owning nothing but a few suits and an old automobile. It was all he needed—all he ever wanted from life.

Or was it? he wondered. Maybe Miles finally realized he'd been a chump all his life. His penury had cost him a wife and a daughter and now he was facing old age and poverty. So when he saw his nest egg, as well as a chance to provide for the daughter he had neglected, he took it. Was that so difficult to understand? Or forgive? What would I do if I found the Fabergé egg? Give it to a Nazi? Or to Miles's daughter? Or would I keep it for my own daughter —or my own old age? I don't know and I don't care because I don't have it and I don't know where the hell it is anyway.

The sudden realization that his mentor, a man he had in large measure patterned his life after, was a thief, had left McGuffin bereft, uncertain now of everything. His entire life, it seemed, was a terrible accident, a cruel joke perpetrated by an old fraud. McGuffin knew his own faults well enough, but he had never seriously padded a bill, or taken any of the opportunities for a dirty buck so often available in his line of work. He knew he would never be rich and doubted that he would leave anything much to Hillary. But until now, filled with Miles Dwindling's virtuous homilies, he had been able to live with the choice he had made eighteen years before. He had chosen to be a white knight, to joust with dangerous and evil men for little more than a pittance, rather than defend them in a court of law for a grand fee. Now he wondered if Miles Dwindling had made a terrible fool of him.

"I haf made a stupid mistake," Kruger said.

McGuffin looked up and blinked. Kruger was pacing behind the desk light. "Me, too."

"Perhaps there is still something ve can do."

"We?"

"You and me. Bring me the egg and I vill release your vife and daughter."

"I don't have it," McGuffin replied.

"But you must know vhere it is. If Mr. Dwindling didn't return it to Klaus then he must haf had it ven I killed him."

McGuffin shook his head. "I went through everything after he died—the office, his apartment, his car—and I found nothing."

"He had it," Kruger said, slapping his fist into his palm, with the sound of a breaking twig. "He may haf hidden it very vell, but he had it—I know that now." He came out from behind the light and stood only a few feet from McGuffin. His pop eyes were alight with anticipation. "A safe!" he exclaimed, thrusting a finger at McGuffin.

"I opened it myself, there was nothing there."

"Hmm—" He considered this for a moment, then exclaimed, "His vife!"

"Divorced."

"Children—?"

"There was—," McGuffin began, then stopped.

"Yes—?"

"A girlfriend. But she died broke a couple of years later."

"*Scheisse,*" he said, punching his palm again. He walked past McGuffin and began to pace behind him. "You knew him better than anyone. He had the egg ven he died, therefore you must know vhere it is."

"If I did, I'd give it to you. In exchange for my wife and daughter," McGuffin added.

"No, no," he spoke from behind McGuffin. "You know vhere it is, but you don't realize that you do. Think. Vhere vuld Dwindling hide something valuable?"

McGuffin thought about it for a moment, then replied slowly, "I don't know."

"You must!" Kruger insisted. "You are the only one who could know! Think, for God's sake, think!"

"It's been eighteen years," McGuffin protested. When he stirred in his chair, Schatze began to growl, but McGuffin went on, undeterred. "Somebody probably found it a long time ago and sold it off piece by piece."

"No," Kruger said. "That is not possible. The egg is somewhere—Dwindling had it—and now I must haf it. If I haf the egg, everything is possible—everything! Do you understand, Mr. McGuffin?"

"I can't say that I do," McGuffin replied. "But I know what you want and you know what I want. So what do you say to a deal?"

"What sort of deal?"

"You return my ex-wife and daughter and I'll help you find the Fabergé egg."

Kruger appeared from behind McGuffin, smiling. "But you haf already made such a deal vit Klaus."

"I'm abrogating it."

The old man laughed softly. "I think you are not a loyal employee, Mr. McGuffin. Nevertheless," he said, hoisting himself up on the corner of the desk, "it is possible that ve might do business. But first you must bring me the egg, then I vill release your vife and daughter."

"Uh-uh. First you release them, then I bring you the egg."

Kruger laughed again. "Mr. McGuffin, you haf already betrayed Klaus. Surely you don't think me such a fool that I vuld put myself in the same position."

"It's got to be my way or not at all," McGuffin insisted.

Kruger shrugged. "Then I vill kill them."

"You're bluffing."

"I believe Mr. Dwindling said something very much like that, just a few seconds before I killed him."

"I don't get it, Kruger. Your beef is with me, not them. Why don't you take me and let them go?"

"My plans haf changed, thanks to you, Mr. McGuffin.

Suddenly I am filled vit love instead of hate. I see a vay to make up for everything I haf lost. But I need your help. Please help me, Mr. McGuffin, so that I won't haf to kill again," Kruger pleaded.

McGuffin stared into his round eyes and nodded slowly. "Okay."

"How much time vill you require?"

"It could take a long time, maybe a month," McGuffin answered.

"You haf a veek."

"A week—?"

"One veek from today your vife and child vill be no more. Do you understand that?"

"Yeah, I understand."

"Then I suggest you get started immediately."

McGuffin climbed to his feet, stared uncertainly at the little man for a moment, then turned and started out of the room. Kruger stopped him before he got to the door.

"I'm sure I don't haf to tell you not to involve the police in our business, Mr. McGuffin," he called.

McGuffin stopped at the doorway and turned to the three men and their dog. "And I'm sure I don't haf to tell you that if anything happens to Marilyn or Hillary, I'm going to kill all of you." When Schatze growled, McGuffin added, "And that goes for your dog, too."

Then he walked out of the house and down the hill to his car. He was halfway to San Francisco before he remembered that he had left his gun in the bottom of the grape wagon in the barn.

3

McGuffin awoke early the next morning to a damp, cold fog, put on his robe and slippers and padded down to the engine cum storeroom of the *Oakland Queen*. Once more he went carefully through the contents of Miles Dwindling's old trunk, hoping to find a previously insignificant but now meaningful clue as to the whereabouts of the Fabergé egg. He turned Miles's magical mystery bag upside down, strewing his burglary tools, disguise kit and false credentials across the deck with everything else, then went carefully through each file, hoping to find a key or claim check or something that would lead him to the egg. It was almost noon when he returned to the wheelhouse, with nothing to show for his effort except the faded, framed photograph of the little girl with Shirley Temple curls. He propped the picture on his desk and began phoning his contacts, some legitimate, some not so legitimate, in the hope that one of them could lead him to Miles Dwindling's daughter.

"Her name, if she hasn't married and changed it, is Ivey Dwindling, and she's probably in her early thirties," McGuffin informed his man at the *Chronicle* who occasionally earned one or two U.S. Grants for the performance of such services. He gave him the names of both her parents, as well as the last known address of her mother, then phoned the same information to his moles at the county clerk's office, the Federal Building, the telephone company, PG&E and the San Francisco Police Department.

"Miles Dwindling," Sullivan the cop repeated. "Wasn't he the private you used to work for who got fuckin' hammered about ten years ago?"

"More like twenty," McGuffin corrected.

"Time flies. What the fuck you want with his daughter?"

"Just find her and you've made five hundred," McGuffin said.

"Big fuckin' deal," Sullivan said, then hung up the phone.

Soon after placing the last call, there was a loud knock on the wheelhouse door. "Who is it?"

"Elmo," his landlord called. "Let me in."

"Not now, Elmo, I'm busy."

"So am I, so open up right now."

"No."

"If you don't open the door you're gonna be in a lot of trouble," the architect warned.

"I'm already in a lot of trouble," McGuffin replied. "So if you don't mind, let's do this some other time."

"I can get a court order, you know."

"But you won't because that would mean hiring a lawyer and we both know you're too tight for that."

"Okay, Amos, you asked for it. I tried to do this in a nice way, like two civilized people, but I see that won't work with you."

"Elmo, there is nothing civilized about throwing a

man out of his home and office—especially when he's in the condition I'm in," McGuffin informed him testily.

"On the sauce again, eh?" Elmo sniffed.

"No, I'm not on the sauce. And if you don't get the hell away from my door right now, you're going to have to add assault and battery to your evict action."

"I'm going, but I'll be back. And when I get back you'd better be gone," Elmo warned.

McGuffin listened as the sound of Elmo's leather heels on the deck faded and disappeared. Then he got to his feet, went into the bathroom and quickly showered and shaved. He slipped one leg into his brown tweed pants, remembered that the matching jacket was now dog food, and stepped back out. He threw the pants in the corner with the shredded jacket and selected another suit, also brown tweed. It was never a conscious decision, but somehow all of his suits and sport coats were brown. Dressed in his new suit and looking much the same as usual, McGuffin started for the door, then stopped and returned to the desk. He removed Ivey Dwindling's photograph from the frame and dropped it into the right-hand pocket of his coat, where he usually kept his gun. He supposed he would have to buy another one.

Ivey Dwindling's last known address was a large frame house in the Avenues, not far from the Pacific Ocean. McGuffin glided to a stop directly across the street and peered at the building through the fog blowing in from the sea. What was once a one-family house was now a run-down building divided into several small apartments. McGuffin knew when he got out of the car that he was only getting wet for nothing, but it was the only lead he had and it had to be checked.

The front door lay partly open, revealing a worn linoleumed corridor flanked on both sides by four flimsy wooden doors. There was a row of mailboxes under the curved stairs leading to the second floor, only a few with names, and McGuffin knew even before he pushed the

buttons that none of the buzzers worked. He pushed them all, waited for a minute, then walked down the corridor to the first door and knocked. A moment later a white-haired black man, wearing reading glasses, opened the door as far as the chain would allow.

"Yes—?"

"My name is Amos McGuffin," the detective said, showing the old man his choirboy smile. "I'm looking for some old friends who used to live here about eighteen years ago—a woman and her young daughter, named Dwindling."

The old man smiled back. "I doubt if there's anybody lived here as much as half that."

"Where can I find the building manager?"

The old man laughed. "Ain't seen one of them in all the time I been here. All I know is I'm supposed to send a check every month to something called Preferred Properties on Market Street. So if this is preferred, you know you don't want to see no unpreferred."

"You're right, thanks," McGuffin said, backing away. There was no sense going further. Ivey Dwindling was part of the unrecorded history of this building.

He walked out the front door, skipped down the front stairs into the fog and hurried across the slick wet street to his car. He was about to get in when he noticed a group of children, unmindful of the dampness, grouped in front of the small grocery store at the corner. It was just the sort of place where Ivey would have stopped for ice cream, McGuffin decided, as he started for the store.

The kids ignored him as he pushed past them and opened the worn wooden door. A bell over the door jingled lightly when he stepped inside the tiny grocery store. There was no doubt the place had been here when Ivey was a little girl, perhaps even when Queen Victoria was a little girl. The wooden floor was worn to hills and gullies, and cartons and cans were stacked haphazardly wherever they could be fitted. McGuffin walked to the back of the small room as the curtains parted and a stooped old lady

appeared. The woman stared silently as McGuffin introduced himself and produced the picture from his coat pocket.

"Shirley Temple," she said, nodding and smiling.

"You remember her?"

"Sure, I remember. She live up the street with her mama," the old woman said, in what sounded to McGuffin like a Russian accent.

"Her name is Ivey Dwindling."

"I call her Shirley Temple. Sweet girl, no trouble."

"Do you know what happened to her?"

"What?" the woman asked fearfully.

"No, no," McGuffin said, shaking his head. "I mean do you have any idea where she and her mother might have moved?"

The old woman thought about it for a moment, then shook her head slowly. "I don't tink so. Her fadder was killed, I tink she get lots of money."

"Why do you say that?" McGuffin asked quickly.

She shrugged. "One day she have nuttin', the next she have a big car, den dey move." It was obvious, the American dream. "Why do you want her?"

"To give her some more money," McGuffin answered.

"Dat's nice," the old lady said. "I wish I could help."

"You might have," McGuffin said. Then he thanked her and left.

The coastal fog changed imperceptibly to rain as McGuffin wove eastward through Golden Gate Park to downtown San Francisco. He returned his car to Gino's service station on the Embarcadero, then hailed a cab to Goody's bar. The first of the after-work crowd had already begun trickling in by the time McGuffin arrived. Goody looked up from the beer he was drawing and called to McGuffin as he hurried to the phone at the end of the bar, "You find Hillary okay?"

"Not yet," McGuffin answered, snatching the phone

from the hook. He dropped a quarter in the slot and dialed his answering service. Mrs. Begelman picked up on the fifth ring.

"Amos McGuffin—any messages?"

"You know, Mr. McGuffin, it's going on two months now I haven't received your check?"

"I'm sorry, I'll take care of it right away," McGuffin promised. "Did anybody call?"

"Anymore I've got a new policy," Mrs. Begelman went on. "First warning, I hold your calls until I get my check; second warning, I stop taking your calls; third warning, you're gone."

"Mrs. Begelman, you'll get your money just like you always do. Now will you please give me my messages?"

"Don't shout, I'm looking." He heard papers being rustled as Mrs. Begelman continued to mutter about delinquent accounts. "Here it is—Lieutenant Sullivan will meet you at Goody's after work. That sounds terribly important."

"Just the messages," McGuffin said.

There were five more, from the *Chronicle,* the county clerk's office, the Federal Building, the telephone company and the PG&E, all of them presently unavailing, but not without some future hope. His federal contact couldn't even find a Social Security number for an Ivey Dwindling, indicating that she had probably applied for her card under her married name, which would make the task that much more difficult. McGuffin thanked her, hung up the phone and walked slowly to the bar. Goody was waiting with a Paddy's and soda.

McGuffin stared thoughtfully at it for a moment, then shook his head. "No thanks."

"You're on a case!" Goody exclaimed brightly.

"I suppose you could say that."

"Big money?"

"No money."

"No money!"

"I'm doing it for love."

Goody was puzzled. "What the hell are you talkin' about?"

"I'll tell you about it later." Goody was trustworthy but opinionated. If he knew that Hillary had been kidnapped, he might go to the FBI despite McGuffin's objections. "How about a plain club soda?"

The barkeep splashed McGuffin's drink in the sink, then filled the glass with club soda. He pushed it across the bar, then watched McGuffin as he drank. "This labor of love, it ain't got nothin' to do with Hillary, has it? I mean she ain't a missin' person, is she?"

"Of course not," McGuffin answered.

"Then where is she if you ain't found her? She's been gone for two days, you know."

McGuffin took another drink, while he thought of an answer. "Marilyn took her on a trip."

"Where?"

"Up north," McGuffin answered, indicating the direction with his chin.

"Up north ... Where up north?"

"Yosemite."

"That's east."

"I was never good at geography."

"You ain't a very good liar either," Goody informed him. "If this is none of my business, tell me. But don't bullshit me, okay?"

"I'm sorry," McGuffin said. "I'll tell you everything just as soon as I can, but not right now."

"Why later, why not now?"

"You asked me to tell you if this is none of your business, didn't you—?"

"I'm not askin' about the case, I'm only askin' why you can't tell me about it now. There's a difference," Goody explained.

"I can't tell you about it now because it's none of your business," McGuffin replied sharply.

"I think I like you better when you're drinkin'," Goody said, then turned and waddled off.

McGuffin regretted his sharp tone, but knew an apology would only open the door to more questions. Until now Goody had always been McGuffin's sounding board, a faithful listener whose astute questions had often gotten a derailed investigation back on track. It would be hard for him to accept, even later, McGuffin realized, that his help could be fatal.

McGuffin was spared further guiltful ruminations by Sullivan's entrance. He was hardly out of his raincoat before McGuffin was at his side.

"What have you got for me?" McGuffin asked.

"Wet as a motherfucker out there," the big cop said, snapping his coat once before hanging it on the wall, spraying water on McGuffin.

"Did you find anything?" McGuffin persisted, following Sullivan to the bar.

"Can I get a fuckin' drink first? Jesus fuckin' Christ..."

"Goody, give him a drink!" McGuffin called. "On my tab!"

Goody looked up, scowled faintly, then reached for Sullivan's bottle.

"Now tell me about Ivey Dwindling," McGuffin urged.

"Can't tell you anything about Ivey Dwindling except that she's the sole survivor of Mary Dwindling."

"Her mother's dead?"

"You got a quick mind, Amos. She died in Acapulco nine years ago, of natural causes, according to the death certificate, leaving a daughter, Ivey, resident U.S."

"Where in the U.S.?"

Sullivan shrugged. "Don't know. I should have a copy of the death certificate in a few days, but it won't tell you that. And it'll be in Mexican," the cop warned.

"I'll manage," McGuffin replied. "What kind of place was she living in? Did she have money?"

"Now how the fuck would I know that? Goody,

71

where's my drink?" he hollered. "I didn't come in here to sober up."

"Don't worry, you'll be drunk in plenty of time," Goody promised as he approached with Sullivan's drink.

"And give Judge Brennan a drink on me," Sullivan said, with a wave to the man huddled over the end of the bar.

"The judge is passed out," Goody said, slamming Sullivan's drink on the bar.

"Then put one in front of him so he'll see it when he wakes up—he'll think it's fuckin' Christmas."

"No more for the judge," Goody said. "And if you're askin' about McGuffin's new job or his daughter, forget it, he ain't talkin'."

"We're not talkin' about his daughter, we're talkin' about his ex-partner's daughter," Sullivan said, reaching for his drink.

"Miles Dwindling's daughter—? What's he want with her? I'd ask him myself except it's none of my business."

"I'm looking for something and she might know where it is," McGuffin answered wearily.

"What?" Goody asked.

"An egg."

"You see what I mean?" the barkeep asked, thrusting a thumb in McGuffin's direction. Then he turned and walked away, muttering, "Ask a civil question and what-taya get?"

"Hey, Amos, why you abusin' the old man?" Sullivan asked.

"I'm not abusing him, I'm really looking for an egg."

"An egg," Sullivan repeated.

McGuffin sighed. "Have you ever heard of the Fabergé eggs?"

"You mean that salty shit you put on crackers?" McGuffin shook his head. "Don't know how people can eat that shit," Sullivan said, lifting his glass.

"The egg I'm looking for is worth a few million dollars," McGuffin informed him.

Sullivan halted the glass inches from his lips. "No

shit?" McGuffin nodded. "You mean it's some kind of fuckin' jewelry or somethin'?"

"Exactly."

"Hmm," Sullivan said, considering so grand a sum. Not even a New York narc could knock down that kind of scratch. "So what's this got to do with your ex-partner and his daughter?"

McGuffin pushed his fingers through his hair and looked at the cop. "It's a complicated story," he warned.

"Goody, another drink!" Sullivan called. "On McGuffin!"

McGuffin lifted his glass of soda, changed his mind and replaced it on the bar. "Shortly after I went to work for Miles, he was hired by a guy named Otto Kruger to steal the egg from his ex-boyfriend, Klaus Vandenhof, which he did. But he apparently decided to keep it for himself, so he told Otto he had returned it to its rightful owner, and that's when Otto killed him."

"And Dwindling had the egg in his possession at that time?" the cop questioned.

"He must have, but I haven't been able to find it."

"So how come you only got around to lookin' for it now?"

"That's the complicated part. For eighteen years Otto Kruger is wasting away in the Napa Hospital, thinking Vandenhof still has the egg. He's also a little annoyed at me for putting him away, so the first thing he does when he gets out is abduct my daughter and her mother."

Sullivan stared uncomprehendingly at the detective for a moment before inquiring dully, "Whattaya mean, 'abducted'?"

"Just that," McGuffin answered. "He came to Marilyn's apartment last Sunday night and he took them away. He left this," McGuffin said, passing the yellowed newspaper clipping to the cop. Sullivan read while McGuffin continued. "So I went to Vandenhof and asked him to help me find Kruger, which he agreed to do, if I would get his egg back from Otto."

"But Otto doesn't have it," Sullivan said, looking up.

"Right."

"He thinks Vandenhof's got it."

"Exactly. And when Otto realized that Miles still had the egg when he killed him, he had a sudden change of plan. He offered to trade me Marilyn and Hillary for the egg."

"I see," Sullivan said, testing the bristles on his chin. "And you think Miles must have somehow got the egg to his wife before he was killed."

"Ex-wife," McGuffin corrected. "There was no love lost between the two of them. If Miles gave her the egg, it was meant to be in trust for his daughter."

Finished reading, Sullivan handed the clipping back to McGuffin. "You're right, it's a fuckin' complicated story. You want my advice?"

"Does it matter?"

"Let me call in the feds."

"Shit," McGuffin said. "We're talking about two human beings, not a stolen car."

"All right, they can fuck up, but so can you, Amos. You don't know where Ivey Dwindling is, or if she ever even had that fuckin' egg. And even if she did, what makes you think she hasn't sold it by now?"

"I realize what I'm—"

"How much time you got?"

"Until Monday."

"Monday? Not even a fuckin' week! You got any idea where Kruger's keepin' 'em?" McGuffin shook his head. "Where'd you see him?"

"At the Hauptmann Vineyard in St. Helena—but they're not there."

"How do you know, did you search the place?"

"No. But I know they're not there," McGuffin insisted.

"How do you know?" the cop persisted.

"I know because Kruger told me they weren't there."

74

Sullivan stared incredulously at the detective. "What, are you fuckin' nuts, McGuffin?"

"I know, I know—!" McGuffin interjected, before the cop could further question his sanity or judgment. "I thought about it and I'm sure he's telling the truth—for two reasons. First, he'd have to be crazy to take his hostages to his own house, and—"

"And he's not crazy?" the cop interrupted.

"Not that way. And second, if they were there, he would have shown them to me, because it would only have strengthened his hand."

"Yeah—?" Sullivan asked, unconvinced. "There's also a third possibility, you know."

"I know," McGuffin replied soberly. "And I want you to remember, in case you have to testify at my trial, that I said to you here in this bar tonight, that if Otto Kruger were to murder my ex-wife and daughter, I could find it in my heart to forgive him."

Sullivan shook his head sadly. "Let me call in the feds, Amos."

"No," McGuffin said. "At least not yet."

"When? How long you expect a fuckin' nut case to remain patient?"

"Vengeance is the only thing that keeps him going. First it was me, now it's Vandenhof. As long as Kruger thinks I have the slightest chance of finding the egg, he'll be patient," McGuffin assured the cop. "But if he gets even an inkling that the FBI is in on this, Marilyn and Hillary are finished. He'll never spare them to save himself. The only thing he wants from life now is to avenge himself on his old boyfriend."

"Such is the power of love," the big cop intoned. "So whattaya want from me now?"

"Patience," McGuffin said. "And keep looking for Ivey Dwindling."

"If she's alive I'll find her," Sullivan promised, as Goody placed a third drink in front of him.

"If who's alive?" Goody asked.

McGuffin looked at Sullivan and shook his head, the signal for silence. Then unthinkingly he reached for the last of his club soda and knocked it back without thinking. He grimaced at the unexpected taste, then turned and hurried out of the bar.

He declined the proffered cab and walked instead to Tadich's restaurant in the financial district, an old establishment with good food and surly waiters, popular with the locals and scrupulously avoided by tourists. He saw several familiar faces, divorced men dining alone, but merely nodded as he was led to a table at the back of the room, anxious to be alone and able to think. He ordered without much thought the pork loin special with baked potato and vegetable of the day.

"What do you want to drink?" the waiter demanded.

McGuffin sighed. "Calistoga water."

The waiter jotted this down and hurried away, leaving McGuffin to contemplate the bottle of Pinot Noir on the next table. How well it would go with the roast pork. But no, I must have my wits about me. Still, a bit of wine can often set the mind dancing to the music of deep thought, he argued. And in his present condition it would only serve to relax and ensure him a good night's sleep, so that he might awaken fresh in the morning, eager to solve the task at hand. Or one bottle could lead to another, followed by a hangover and a wasted day. Fairly and objectively, McGuffin presented both sides of the argument to himself, then made his decision. When the waiter next appeared, he called, "May I see the wine list?"

A short while later, with one glass of Pinot Noir under his belt, the ideas began to come. He thought of hiring a private investigator who specialized in missing persons, then wondered if it was somehow improper for one PI to hire another. Except for the damage to his ego, there seemed no reason not to do it. It was an idea he would keep in reserve. He could also place a personal ad in several newspapers across the country, offering a re-

ward for information leading to Ivey Dwindling. After the second glass of wine the ideas came fast and furious, and all of them, he came to realize as the meal and bottle came to an end, were nearly worthless. McGuffin wrestled valiantly against the urge for further drink, slammed his opponent to the mat, paid his bill and took a cab back to the *Oakland Queen.*

Perhaps, had he not drunk the wine, he reasoned later, he would have been alerted by the rush of cool air that greeted him when he opened the wheelhouse door. Knowing that he would never leave a window open during the rainy season in San Francisco, he would have realized that someone else had, and that someone was possibly still in the room. He would have then backed out and slammed the door, and got the hell out of there as quickly as he could, in that his gun was lying in the bottom of a grape wagon in St. Helena. But under the state of dullness, induced by the wine, McGuffin went a step too far into his dark office, felt something like a soft explosion to the back of his head and fell, still faintly conscious, to his hands and knees. The first thing he saw, when the desk lamp was switched on, was Klaus Vandenhof squeezed into his chair, pointing a Luger at him, probably the same one he had used to shoot partisans during the war.

McGuffin touched his hand to the numbness at the back of his head, came away with a little blood, then looked up at the fat man and inquired, "Does this mean I'm fired?"

"Terminated," the fat man corrected. "Toby, get him up."

Two arms went around McGuffin's back and he was pulled to his feet. He sagged against the chart cabinet as Toby closed the door, and then reappeared in front of him. His gun was a small Beretta, sufficient to kill, but fortunately not heavy enough to fracture McGuffin's skull—at least not in Toby's hands.

"Get your hands up," the little man ordered. McGuffin raised his hands and looked around the room while Toby carefully unbuttoned and turned his jacket back. The place had been torn apart. "Where's your gun?" Toby asked.

"In a grape cart," McGuffin answered.

Slow as an aging quarterback, Toby cocked his gun arm, preparing a second blow to McGuffin's head, a split second before the detective's forearms fell heavily on the little man's clavicles, disengaging him from his gun and driving him to the deck. McGuffin dived in the direction of the clattering gun, then froze at the sounds of an explosion and the whine of a slug off the deck, just inches from his extended right hand.

"Go no farther, Mr. McGuffin," Klaus Vandenhof warned.

"You remind me of an old girlfriend," McGuffin grunted, as Toby groaned.

"Are you all right, Toby?" Vandenhof asked.

"I think he broke my shoulder," Toby moaned. "I'm gonna kill him, Klaus. No matter what you say, this time I'm gonna kill him."

"Later, Toby," Vandenhof said soothingly. "Right now I want you to get up and get your gun." Toby climbed to his feet, grunting and working his injured shoulders. "And don't lose it again," Vandenhof said sternly, as Toby stooped to recover the Beretta. "Now you, Mr. McGuffin, will get to your feet," he instructed, motioning with the Luger.

McGuffin climbed to his feet, raised his hands lazily and looked around. "If you'll tell me what you're looking for, maybe I can help you."

"You know very well what we are looking for, Mr. McGuffin. And if you wish to spare yourself a great deal of pain, you will tell us where it is," Vandenhof replied, with a faint note of irritation.

"You're a tough client," McGuffin said. "And I'm a

good detective. But be reasonable, I've only been on the case for two days."

"More than enough time to *abrogate* our agreement, it would seem," Vandenhof remarked pointedly.

"Abrogate—?" McGuffin repeated, remembering with a sinking feeling the last time he had used the word.

"Please, spare me your innocent protestations," Vandenhof said, waving the Luger, as if to shoot McGuffin's words out of the air. "My informant in the Kruger camp told me everything that transpired at the winery yesterday evening."

"Then he must have also told you I was about to become dog food if I didn't at least pretend to agree to a deal with Otto."

"I overestimated you, Mr. McGuffin. I thought you were a man who put family ahead of money, but I see I was mistaken. You are out to make the best deal you can for yourself, without regard for the safety of your wife and daughter. This makes me very sad, of course. But you also betrayed me, and this makes me very angry," he said, eyes pinched and glittering in the blue glow from the desk lamp.

"I didn't betray anybody," McGuffin insisted. "Not my family and not you. And if you think I'd make a deal with a homicidal maniac, you're as crazy as he is. Don't you think I know that Kruger will kill my wife and daughter as well as me, even if I were to give him the egg? Remember, he didn't abduct them to get the egg—he thought you had it—he only took them to get me. Then when he saw a chance to get the egg as well as have his revenge, he decided to have both. But my deal is still with you and Toby, because you're my best chance to get Marilyn and Hillary out alive. All you want is the egg and all I want is them."

"He's lying through his teeth," Toby said, appearing in front of McGuffin, Beretta back in hand.

"I'm afraid Toby is right," Vandenhof said sadly. "You're a greedy man. You want the Fabergé egg *and*

your family, but you can't have both. Give me the egg, Mr. McGuffin, or I will allow Toby his fondest wish."

Toby aimed the cocked gun between McGuffin's eyes and laughed softly. McGuffin had no doubt, he was every bit as dangerous as Crazy Otto. For the second time in scarcely more than a day, he would have to bargain for his life with a homicidal maniac.

"You've already searched the place, you know the egg's not here."

"Then where is it?" Vandenhof demanded. "Your partner had it when he was killed, you must have it!"

"I don't," McGuffin said.

"Let me kill him," Toby said, dangerously gripping and regripping the gun.

"But I know where it is."

"You do?" Vandenhof asked breathlessly.

"Where?" Toby asked.

"In Mexico."

"Mexico—?"

"He's lying again," Toby warned.

"Where in Mexico?" Vandenhof asked, laying a hand on Toby's gun arm and easing him to one side.

"Uh-uh," McGuffin said. "If I tell you that I've lost my bargaining chip."

"If you don't you've lost your life," Toby said.

"Killing me won't get you the egg," McGuffin explained to Vandenhof.

"But it will reduce the number of hunters by one," Vandenhof explained to McGuffin. "And I'm sure you realize, there's little reason for Toby to hesitate, Mr. McGuffin. Not only does he dislike you intensely, he also knows that Otto would logically be the one charged with your murder. So tell me, Mr. McGuffin, right now, where in Mexico is the egg?"

"I don't yet know exactly where it is, but I'll find out very soon," McGuffin said. "I just learned that Mrs. Dwindling is living somewhere in Mexico. She has the egg."

"How do you know this?" Vandenhof asked.

"I know because I gave it to her, eighteen years ago. I found the egg among Miles's things after he was killed, but I had no idea what it was. I just put it in a box with everything else and drove over to Mary's house—she was living out in the Avenues with her daughter, Ivey, who was then about five years old—and I gave it all to them. Mary had no idea what the egg was either, but Ivey thought it was pretty, so they decided to keep it."

"Pretty," Vandenhof repeated. "Describe it for me."

"Well—that was a long time ago . . ."

"A Fabergé egg is unforgettable."

"Let's see . . . ," McGuffin mused, trying to remember Vandenhof's description of the egg, while hoping that he had forgotten mentioning it. Toby had fortunately been out of the room at the time. "As I remember, it was mostly white, with some gold eagles," McGuffin began slowly. "And inside the eagles were little portraits. And it was sitting on a pedestal that had some gold and jewels on it, right?"

"And inside?" he asked, his expression noncommittal.

"Inside," McGuffin began, remembering the globes with two maps of the Russian Empire inset in gold, then suddenly shifting—"we didn't know you could open it."

Vandenhof smiled. "Nor would anyone unfamiliar with the genius of Fabergé." The smile disappeared as quickly as it had come. "Why did you not tell me this before?"

"It didn't dawn on me until later that the two eggs were the same," McGuffin answered.

"And when it did you started looking for Mrs. Dwindling?" Vandenhof asked. McGuffin nodded. "Why not the daughter?"

"The daughter—?"

"It seems to me that she would be the one most likely to discover the value of the egg, not an old woman."

McGuffin shook his head slowly while he tried to think of an answer. "I've given that a lot of thought," he began, then stopped.

"And—?"

"Forget about her," McGuffin urged. "She disappeared years ago."

"With the egg perhaps."

"Not a chance," McGuffin said, shaking his head. "If she had taken the egg she would have sold it. And if she had, the whole world would know about it." Vandenhof listened intently. As McGuffin had hoped, the fat man wanted desperately to believe that his precious egg was tucked away safely in the musty jewel box of an unsuspecting old lady. "I'm sure the old lady has the egg and if you'll just give me a little time I can get it for you," McGuffin promised.

"He's just playing for time. Let me kill him," Toby urged.

"I have waited for eighteen years, Toby. What harm is there in waiting a little longer? Especially if you accompany Mr. McGuffin to Mexico—just to ensure that my interest in the egg enjoys precedence over Otto's," Vandenhof said with a smile and a nod to McGuffin.

Toby brightened. "Yeah, I think I might enjoy that."

"Forget it," McGuffin said. "We wouldn't get as far as Tijuana before one of us killed the other."

"You are in no position to dictate to me!" Vandenhof replied sharply.

"I'll dictate to you and you'll like it," McGuffin responded. "Because I'm the only one who can lead you to the egg and you know it, even if your little friend doesn't. So if you want to kill the goose that can find the golden egg, go ahead. Otherwise get your ass out of my chair and get the hell out of here because I've got work to do."

The fat swelled and closed around Vandenhof's surprised eyes, while a chuckle began building in his bowels, puffing him up like a pigeon. The laughter that finally rolled from his lips seemed powered by a jolt of electricity that racked his body with spasms and filled his eyes with tears as he struggled for speech. "Your audacity...! I can scarcely...! Priceless...!"

"And I thought Germans had no sense of humor," McGuffin interrupted.

"Oh, I am amused, sir, most amused, I assure you!" Vandenhof spluttered as he wiped his eyes with the back of his gun hand.

"Let me kill him," Toby said flatly.

"His needle is stuck," McGuffin said, jerking a thumb at the gunman. "So what's it gonna be? If I'm working for you, I work alone. You call it."

"Very well, Mr. McGuffin, we'll do it your way," Vandenhof said, lifting his jacket and sliding the Luger into a shoulder holster.

"Don't do it, he's conning you," Toby said.

"Perhaps," the fat man grunted, as he pushed himself out of the chair. "So just to be safe, we'll be watching him very closely. Fair enough, Mr. McGuffin?"

"Fair enough," McGuffin said, stepping aside for the large man as he lurched heavily in the direction of the door. "I'll contact you when I have the egg."

"See that you do, sir," he said, with a backward glance. "And you will find me most willing to aid in the return of your wife and daughter. Betray me, however, and you will never see them alive. Is that clear?" he asked, reaching for the door.

"Perfectly," McGuffin answered.

"Good. Come, Toby," he said, opening the door.

Toby's eyes danced indecisively between McGuffin and Vandenhof. When Vandenhof repeated his name, Toby shook the Beretta in McGuffin's face and vowed, "The next time."

McGuffin smiled and followed Toby to the door. "There's one other thing," McGuffin said, as Vandenhof stepped through the hatchway.

"Yes—?"

"That gun," he said, pointing to the Beretta in Toby's hand. "I'd like to borrow it."

"You what—?" Toby said.

"It'll just be until I get the egg," McGuffin assured

him. "I, uh—misplaced mine—and I might have need for one."

"How about just a bullet?" Toby asked.

"Toby . . . ," Vandenhof said warningly.

"I don't care, this time he's gone too far," Toby complained.

"It will only be for a short while, Toby. And you do have plenty of others," Vandenhof soothed as he took the gun from Toby's hand.

"But that's my favorite," Toby wailed, as he watched the detective take it.

McGuffin stuck the gun in his belt and blew Toby a kiss. "Thanks, sweetheart."

"You see that? He's making a fool of you," Toby said, as he followed the fat man down the gangway.

Grinning, McGuffin closed the door on Toby's continuing complaints. Buying a handgun in California is dangerously easy, but borrowing Toby's was infinitely more fun.

4

McGuffin was under no illusion concerning his thespian abilities. That he had managed to convince Vandenhof (if not Toby) that the Fabergé egg resided at present in a foreign land, in the custody of a dead woman, and not the dead woman's daughter, was evidenced by the fact that he, two days later, was still alive. But Vandenhof had not believed for a moment that McGuffin would take pains to see that he and Toby were apprised of the recovery of the egg—no more than McGuffin believed that he and Toby would aid in the recovery of Otto's hostages in exchange for this courtesy. But that was fine with McGuffin. He and Vandenhof were a pragmatic pair, each of whom knew exactly how far to trust the other. Until McGuffin had the egg (and until Vandenhof knew it), each would behave like a perfect gentleman. Thereafter the egg hunt would turn mean and ornery.

The truth of this was provided on Friday night when

he left the *Oakland Queen*. It had been the kind of foggy, rainy, San Francisco day that allows the night to slip in unnoticed by all but clock watchers. Weather was not McGuffin's concern. He had spent virtually all of the last forty-eight hours searching desperately for a U.S. citizen named Ivey Dwindling who had once resembled Shirley Temple, and at the end of all that time he knew little more than that. He had alternately blandished and berated his corps of informants, run off on any fool's errand suggested by their flimsy evidence, run up a phone bill that would saddle generations of McGuffins to come, and yet it was as if Ivey Dwindling had gone to the moon.

He hesitated briefly at the end of the canopied gangplank, pulled his hat down and his collar up, then stepped off into the wet night. He walked only a few steps when the headlights of a waiting car flashed on him and, a moment later, the car drew abreast of him. McGuffin stopped as the window on the driver's side slid down to reveal Toby's surly countenance. There was someone beside him on the passenger seat, not Vandenhof, but a younger man with a grim look on his whiskered face, as if he'd been sitting stakeout for too long without relief.

"What are you doing in San Francisco on such a lousy night when you could be in Mexico?" Toby asked.

"I told you before, but I'll tell you once more—I work alone," McGuffin replied.

"Klaus is beginning to think you don't work at all. He's beginning to think you're playing him for a sucker."

"But I'm sure you're doing your best on my behalf."

"I managed to get you a few more hours to live, if that's what you mean."

"Thanks."

"After that Klaus stops believing in three things— Mexico and the Easter bunny."

"What's the third?"

"You," Toby answered, as the window slid up and the car rolled away.

McGuffin released his grip on the Beretta, removed

his hand from the raincoat pocket and continued on down to the World Trade Club in search of a cab. He changed places with an elegant couple who looked as if they'd come up from a place like Hillsborough, then ordered the driver to take him to Goody's, a long way from Hillsborough. The woman's smell remained until he opened the cab door in front of Goody's and stepped out.

Goody's saloon smelled like cigar smoke and stale beer, and the light seemed even dingier than usual when McGuffin stepped inside. Maybe it was the fog—or his mood, McGuffin decided, as he picked his way through the remnants of the Friday evening drinking session, acknowledging greetings, working his way steadily toward Sullivan, who was regaling a group of fellow officers with a police story.

"So the car's layin' up against the tree, the guy's fly is open and the broad's blouse is unbuttoned. So I ask him, what are you doin', drivin' and playin' hanky-panky at the same time? And he says, real indignant, even though he's shitface, 'Officer, I'll have you know that we are an old married couple.' But when I check both the licenses I see the names are different, so I say, 'What's this, I thought you were married?' And he says, 'Not to each other.'"

"Sully, can I talk to you?" McGuffin asked when the laughter cleared.

"Sure thing," Sullivan said, then followed McGuffin to one of the scarred wooden tables opposite the bar. He slid a chair noisily across the chipped tiles, then sat and looked across the table at McGuffin. "You look like shit," he observed.

"I feel like shit."

"Nothin' on the daughter?"

McGuffin shook his head. "I'm beginning to think she's a fake—just like Miles."

The cop shrugged his thick shoulders, dangerously straining his cheap blue suit. "Everybody steals."

"I need help," McGuffin said.

"You want me to call in the feds?"

"Not that kind of help—at least not yet. A couple of nights ago I sold Vandenhof a bill of goods. I convinced him that Miles's wife is still alive, living somewhere in Mexico with the egg. I told him I'd get it and then see that he got it, in exchange for helping me get Marilyn and Hillary. Naturally he knows that if I find the egg I'll go straight to Otto with it, and I know he has no intention of ever helping me, but that's not the point. The point is it's been forty-eight hours and I'm still in San Francisco when I should be in Mexico and the fat man is getting jumpy."

"And you think he might blow you away?"

"Not him, his little friend. He was waiting for me when I came off the boat tonight. I need a couple of cops to sweep the waterfront, Sully. Can you help me?"

"Two cops twenty-four hours a day—?" Sullivan pondered. "That'll cost you, McGuffin."

McGuffin was surprised. But as the cop had warned, everybody steals. "How much?"

"A drink."

McGuffin smiled. "Thanks, Sul."

"But I wish you'd let me call in the feds. We could form a joint task force—you, me, a few good cops, the feds and a bunch of helicopters. We'd be inside that fuckin' winery before they knew what fuckin' hit 'em."

"I'll let you know," McGuffin said, getting to his feet.

Goody was waiting when they pushed their way back to the bar. "What are you two guys up to?" he asked.

"Just having a drink together," McGuffin answered. "Make mine Calistoga water."

"On McGuffin," the cop added.

Goody looked from one to the other for an explanation, saw that none would be forthcoming, shook his head irritably and went to get their drinks.

"Any messages?" McGuffin asked, when Goody returned with their drinks.

"Only your answerin' service," Goody said, dropping their drinks heavily on the bar. "The old biddie says to remind you you ain't paid your bill."

"Shit," McGuffin said, digging into his pocket. Coming up empty he asked, "You got a quarter?"

Muttering, Goody slapped a quarter on the bar. McGuffin picked it up and walked to the pay phone at the end of the bar. He had to wait while a lawyer with a young woman on his arm explained to his wife that he wouldn't be home for dinner because he was meeting with a client.

"Marcie, that's the truth," the lawyer whined. Then, "Marcie, don't you dare hang up! Marcie!" He hung up the phone and turned to the young woman. "It's okay."

McGuffin dropped the quarter in the box and dialed his number. Mrs. Begelman picked up only after several rings. "I hope you don't keep potential clients waiting this long," McGuffin said.

"You know, Mr. McGuffin, for a man who doesn't pay his bill for more than two months, you got some attitude."

"I'm sorry, I forgot, I've got a lot on my mind," McGuffin apologized.

"Me, too, like the rent," Mrs. Begelman put in.

"I'll send it right away," he promised. "Do you have any messages?"

"One."

"From who?"

"Your ex-wife."

"Marilyn!?"

"You got more than one?"

"Are they all right? Where is she, what'd she say?" McGuffin blurted.

"Not so fast," Mrs. Begelman interrupted. "You remember what I said, no money, no messages."

"For God's sake, Mrs. Begelman, you'll get your money! Tell me what she said!"

"She didn't say anything."

"What—?"

"It was a collect call, I refused the charges," she said.

"No..." McGuffin breathed. "You didn't."

"I did."

McGuffin felt his heart pounding irregularly in his chest. In a moment he would begin to hyperventilate, perhaps lose the power of speech. "Mrs. Begelman, you don't know what you've done," he fairly gasped. "She's been abducted, she's in great danger. She was calling to tell me where she's being held. She'll never get to a phone again. And you—you money-grubbing old yenta—you refuse to accept the charges! Are you out of your mind!"

"That sort of talk, Mr. McGuffin, is hardly going to help matters."

An anguished sound escaped from McGuffin's lips before he was able to bring his voice under control. "You're right, I'm sorry. So please, Mrs. Begelman, just tell me where she was calling from."

"How would I know? The operator said she had a collect call from Marilyn McGuffin and would I accept the charges, and I said no and hung up."

"You hung up...."

"I warned you, Mr. McGuffin."

"Yes—yes, you did," he admitted. "And now I'm going to warn you, Mrs. Begelman. If Marilyn or anyone else calls, you will take the message, because it may be a matter of life and death—including your own. And you will stop nagging me about a lousy hundred bucks! You'll get your money just like you always have! Do you understand, Mrs. Begelman?"

"Well, aren't we getting huffy," she said.

"Mrs. Begelman!" McGuffin shouted, turning heads at the bar.

"I understand!" she shouted back.

"Good," McGuffin said. He hung up the phone and rested his head against the wall.

Sullivan slid off his stool and walked across the room to McGuffin. "What is it?" he asked.

McGuffin lifted his head and turned slowly to the cop. There were tears in his eyes. "They're alive," he said in a choked voice. "They're alive."

5

McGuffin was awakened from his best sleep in many nights by the ringing of the phone. Unimpeded by a hangover, he managed to snatch the receiver from the cradle before the second ring and answer in a clear voice, "McGuffin."

"Is this the Mr. Amos McGuffin who was once employed by Miles Dwindling?" a woman inquired hesitantly.

"It is," McGuffin answered. "Who is this?"

"Shawney O'Sea."

"And what have you got to do with Miles Dwindling?" McGuffin asked, adjusting himself on one elbow.

"He was my father," she replied.

He bolted to a sitting position, excited but cautious. "Let's have that name again."

She repeated it, then added, "But it used to be Ivey Dwindling."

"Eureka!" McGuffin whispered. "Where have you been? I've been looking everywhere for you."

"You have?" she asked, in a puzzled voice. "I thought I was looking for you."

"You were look—! Never mind, where are you?"

"I'm staying in a friend's apartment," she answered, and gave him an address on Leavenworth Street.

"Don't move, I'll be there within half an hour," McGuffin said, springing from the bed.

With three minutes to spare, McGuffin alighted from a cab on Leavenworth Street near the Filbert Street steps on Russian Hill, one of the steepest grades in the city. The house was an ugly stucco fortress, rising straight up from the edge of the sidewalk, a green wall with a few small windows and an arched gateway at one side. McGuffin pushed the iron gate open and started up the stone stairs to the first of four landings stepped against the hill. There appeared to be four apartments in the building, with an entry off each of the landings. McGuffin stopped at the first, the address she had given, and rang the bell. A moment later the door opened and McGuffin stood staring at the woman who claimed to be Miles Dwindling's daughter.

"Mr. McGuffin?" she asked.

"That's right," he answered, studying her closely, looking for some resemblance to Miles Dwindling. She had the same lean frame and seemed the right age, about thirty, but beyond that she could be anybody's daughter, McGuffin decided.

"Please come in," she said, in a husky voice.

McGuffin stepped inside and she closed the door after him. Her hair was long and deeply red, glossy as a sorrel thoroughbred, but a bit tousled, falling over one eye. She brushed it back with a well-manicured hand and led him into the living room. McGuffin stopped in the middle of the room, removed his damp hat and looked around. The place looked as if it had been furnished by a dowager aunt, with fringe on the lamp shades and doilies on everything else.

"You'll have to forgive the mess, I just arrived from the airport an hour ago," she said, slapping at the wrinkles in her blue silk dress. It had been chosen to set off her blue, almost violet eyes, as well as her long, smooth body.

"You look fine," McGuffin remarked. "Whose place is this?"

"It belongs to an actor friend from New York. I believe it was left to him by an aunt. Can I take your hat and coat?"

"I'll just throw it here, if that's all right with you," he said, dropping his hat on a red velvet couch.

"Fine," she said. "I'd offer you coffee, but I don't know my way around the kitchen."

"That's all right," McGuffin said. When he dropped his coat on the couch, Toby's gun made a clunk against the leg. He remained standing, waiting for her to take a seat, but she was content to lean against the piano, hair falling over one eye, as if she was about to sing a torch song. "Miles Dwindling's daughter," he said.

"Yes," she answered, brushing her hair back again.

"Do you mind if I see some identification?"

"What—?"

"It's standard procedure in such matters," McGuffin said with an easy shrug. "But if you'd rather not..."

"No, it's quite all right," she said, pushing off the piano. She walked across the thick Oriental carpet and through an open door to a large bedroom. There was a suitcase on the bed and a leather Coach bag beside it. She returned with a red leather wallet, opened it and began laying cards on the piano as if she were dealing blackjack.

McGuffin approached and looked over her shoulder. The several cards were in the name of Shawney O'Sea, including one from the Screen Actors Guild. "You're an actress?"

She shrugged. "The jury is still out."

"Do you have anything in the name of Ivey Dwindling?"

"Not with me."

"Driver's license?"

She shook her head. "I live in New York," she said, pointing to her address.

"Then you have nothing to prove you're Ivey Dwindling?"

"Of course I do. But I had no idea I'd be asked to produce it," she answered peevishly as she gathered up her cards. "I've called myself Shawney O'Sea for more than ten years, thinking that it would help my career—which it hasn't, I might add. I just wish I knew what the hell was going on," she said, stuffing the cards into her wallet. "I haven't been called Ivey since I was in high school, now suddenly everybody expects me to answer to that name. Wait, I do have something!" she remembered, delving back into the wallet. She handed McGuffin a crumpled, graying card. It was an identification card from the New York High School of Performing Arts, with the name and signature of Ivey Dwindling still faintly legible. "I keep it as a joke," she said.

"I'm glad you do," he said, returning the card. "Now tell me who else suddenly expects you to answer to that name."

"Mr. Kemidov," she answered.

"Kemidov—?"

"You don't know him?" McGuffin shook his head. "Well, he certainly knows all about you. And me," she added. "I'm sure he's with the KGB."

"KGB—?" McGuffin repeated. "Why don't you start from the beginning. Tell me all about Kemidov and how you happened to come looking for me."

"Let me tell you everything just the way it happened, beginning with yesterday morning," she suggested. McGuffin nodded. "I received a call from a woman with a rather heavy Russian accent, although I didn't know immediately what it was. She said she represented a European film company that was interested in me for an international role, and could I come and meet the pro-

ducer, Mr. Kemidov, as soon as possible. Naturally I flew —to a rehearsal studio in the theater district, where I met the woman with the Russian accent. She sat me down on a folding chair in the middle of a big empty room and then walked out, leaving me alone for several minutes. I know," she said, waving her hands helplessly, "you think I should have gotten up and left right then. But in this business you never know what to expect."

McGuffin waited while she paced thoughtfully across the room to the window, beyond which a light rain had resumed falling. She gazed at it with little interest, before turning back to the detective and continuing her story. "Finally the door opened and a man entered the room. He was about sixty-five, but trim, with salt-and-pepper hair cut very short. He introduced himself as Mr. Kemidov and called me Miss Dwindling. I was amazed. I asked him how he knew that name and he told me he had known me for eighteen years. I didn't know what he was talking about, but I was suddenly very frightened, so I tried acting tough. I told him I had come about a movie, but if there was no movie I was leaving. Then when I tried to get up he pressed me back down in the chair. He was incredibly strong for an old man, and I was suddenly terrified. I begged him to let me leave, but he said, 'Not until you have heard the story of my movie.'"

She took a few steps toward an embroidered chair, started to sit, then quickly straightened up. "He said his movie was about a Russian officer's search for a Fabergé egg that had been stolen by a German officer during the war," she went on, working the wallet in her hands like an exercise ball. "He said it was a treasure that belonged to the Russian people and the officer had dedicated his life to its return. Several times he nearly had it, but each time the German escaped with it. Almost twenty years ago he traced the egg to California. He was all set to take it from the German, when suddenly a private investigator robbed him of it before he had the chance. And that's when I realized it wasn't a movie," she said, turning her wide vio-

let eyes on McGuffin. "You do know who that private investigator was, don't you, Mr. McGuffin?"

"I'm afraid so," McGuffin, the unwitting accomplice, answered.

"He said my father stole the egg on behalf of the man who later killed him, Otto Kruger. And all during the time Kruger was in prison, Mr. Kemidov assumed he had the egg hidden away someplace. But recently he found out that Kruger never had the egg, that my father had it when Kruger killed him. In fact that's why my father was killed, according to Kemidov. He claimed my father refused to turn the egg over to Kruger as he had agreed. Is this true, Mr. McGuffin?"

McGuffin nodded. "Did Kemidov tell you how he learned your father had the egg and not Kruger?"

"Yes," she said, sinking to the chair. She leaned forward, arms on thighs, and stared into the empty space between herself and the detective. "He said his agents have been watching Kruger since the day he was released from prison. He knows that you contacted Kruger and tried to sell him the Fabergé egg. He also knows you contacted the German officer who had originally stolen it. He knows you have the egg, Mr. McGuffin, and he thinks you're about to sell it to the highest bidder. That's why he sent me. He told me to tell you that if you attempt to deliver the egg to either of them the lives of both you and your loved ones will be in grave danger. Those were his words as he told me to deliver them," she said, looking up from the blank space and fixing her violet eyes on McGuffin.

"I see," McGuffin said, nodding slowly. "In other words I'm to give the egg to you and you'll deliver it to him in New York."

"No," she answered. "You're to deliver the egg to Mr. Kemidov yourself. All I'm supposed to do is warn you of the gravity of the situation. After that he'll be in touch with you."

"I don't understand," McGuffin said, hanging his

hand from the back of his neck and staring at the Oriental carpet. "If Kemidov thinks I have the egg, why didn't he come directly to me? Why did he go through you?"

"Because he thought at first that you were acting on my behalf," she answered, getting to her feet. "He assumed my father had managed to get the egg to me and now you were selling it for me. But finally I managed to convince him that I didn't have the egg, and there's the rub."

"The rub—?" McGuffin inquired.

"If I don't have it"—she said, pointing first to herself, then McGuffin—"you must."

"Then why didn't he cut you loose then and there?"

"Because he blames me for what my father did to him. If he doesn't get the egg, he'll kill me," she said, turning her hands palm up. "And you, too," she added. "The man is obsessed with the Fabergé egg, Mr. McGuffin. I'm convinced he'll kill anyone to get it."

"Did he say he was KGB?" McGuffin asked.

"He didn't have to. He spoke of his agents as if he had a great network at his beck and call. It might sound hysterical, but I'm convinced that Mr. Kemidov is a member of the KGB," she stated firmly. "Please, Mr. McGuffin, you must give him the egg."

"I don't have it," McGuffin replied.

"Don't have it—? You mean you sold it?" she asked, eyes wide.

"I mean I've never even seen the goddamned thing," McGuffin shot back.

"You're lying—!" she gasped.

"Yeah, I'm lying! For the last eighteen years, thanks to your old man, I've been getting shot at, knifed and beaten up more than a high school teacher. All I own in life is a seven-year-old clunker and four brown suits—no, make that three, one of them got chewed up by a dog— but in reality I'm an eccentric millionaire with a Fabergé egg stashed away in a gumshoe box. Believe me, I don't have it!"

"Why should I believe you when you don't believe me?" she demanded. "Did I ask you for identification? I told you I'm Ivey Dwindling and that should be good enough! I was born thirty-one years ago in San Francisco where I lived for ten years before moving to Acapulco with my mother! I went to high school in New York where I lived with my aunt until I began pursuing an acting career under the name Shawney O'Sea, and I can prove all of it if you want to come to New York with me!" she exclaimed, brushing angrily at her fallen hair. "You're the one who got me into this mess—you and my father—and now you're acting as if it's my fault somebody wants to kill me!" she concluded, as tears began welling in her eyes.

"I had nothing to do with it!" McGuffin protested. "And I've already got too many other lives to worry about to take you on as well!"

"I'm not looking for protection, I'm looking for the egg!" she cried. "I thought you might help me, but I was wrong, so let's forget about it! Just take your silly hat and get out of here!"

McGuffin picked up his damp fedora and looked closely at it. "This is my rain hat," he explained.

"Whatever it is, please take it and go," she said, pointing to the door.

McGuffin picked up his raincoat and walked across the rug to the foyer. There he stopped and turned, idly twisting the hat in his hands. "What do you intend to do now?" he asked.

"What I came to do—find the egg and return it to Kemidov," she replied, crossing her arms over her chest.

"You know you'll be giving up a couple of million dollars," he warned.

"I'd rather give up a couple of million dollars than a couple of innocent lives. Or one, anyway," she added.

McGuffin stared, trying to figure her out. If she was who she said she was, she might be able to help him find the egg. But if she did, he would have to betray her. He would have to take the egg from her and deliver it to

98

Kruger in exchange for Hillary and her mother, leaving Shawney, or Ivey, out in the cold with Kemidov. It was a cruel choice, but McGuffin was up to it.

"Okay, I'll throw in with you," he said. He walked across the room, hand extended, and stopped in front of her.

Her arms remained folded over her chest. "Why the sudden change of heart?" she asked.

"Because I don't want to see a couple of innocent people get killed either," he answered.

Her violet eyes grew soft as she slowly untwined her arms and reached for his hand. "Partners," she said.

"Partners," McGuffin repeated, taking her cool, soft hand in his. He wondered what Miles Dwindling would make of his pragmatism now.

"Well—now what do we do?" she asked.

"We go on an egg hunt," McGuffin answered. "But first you'd better get into something more practical. That silk dress makes you look like a tourist."

She regarded the sky-blue dress sheepishly. "I'd forgotten that San Francisco could be so cold. I'll just be a minute," she said, tossing her wallet on the couch, then turning and walking quickly to the bedroom.

When she closed the door, McGuffin pounced on the wallet. He found a few more identification cards, all in the name of Shawney O'Sea, as well as several hundred dollars in cash and traveler's checks. He also found a folded Pan Am envelope containing a receipt from a New York–to–San Francisco flight and an open return. He returned everything to the wallet and replaced it on the couch, then sat and waited for her return.

She emerged from the bedroom a short while later, looking very preppy in a long tweed skirt, loafers and turtleneck sweater. She trailed a Burberry raincoat across the carpet, which she allowed McGuffin to help her into.

"That's more like it," he said, steering her to the door.

They walked quickly through the gray drizzle as far as Union Street before McGuffin managed to hail a cab.

"The *Oakland Queen* on the Embarcadero," he ordered, as he followed her into the back of the car.

"What's that?" she asked.

"My office," he said, as the cab pulled away. "I've got a trunk full of your father's things I'd like you to look through—just in case it might jog something."

"What sort of things?"

"Files, a few mementos from the office, his magical mystery bag . . . I'd like you to go through the papers, look for a familiar name, an old friend, maybe even a relative. Or a place. Anything that might tell us where he'd stash a piece of hot jewelry."

"What do you mean, 'his magical mystery bag'?" she asked, laying a hand on McGuffin's knee.

"That's what your father called the leather valise he used to carry his burg—detective tools. Why, does it mean anything to you?"

"It sounds theatrical—like a magician's prop."

McGuffin shook his head. "It was just a name he gave it."

"Yes, but why?" she asked, turning to him. "Did you examine it closely?"

"Of course I examined it closely. What kind of detective do you think I am?"

"You're sure there was no false bottom or secret compartment or anything like that?" she persisted.

"Now *you* sound theatrical," McGuffin said. "Believe me, the egg is not in the bag."

"I believe you," she said, batting her violet eyes.

"Good."

"But I'd still like to have a look for myself."

"Just what I like, a partnership founded on trust," the detective said, glancing through the window at the fog and rain.

The moment he saw the patrol car parked rakishly in front of the *Queen,* light flashing, one door hanging open, he realized what had happened. Someone other than

Vandenhof, who had already been through the place and found nothing, had broken into his office while he was at Shawney's apartment. "Shit!" he exclaimed, digging into his pocket for a roll of bills. He thrust a ten on the driver and jumped out of the car a moment before it came to a full stop.

"Wait!" Shawney called, as McGuffin dashed up the gangplank and down the corridor.

The puzzled tenants watched from open doorways as their security officer, followed by a beautiful redhead, ran past and up the gangway, only seconds behind the cops. He scaled the stairs in threes, then froze to the deck in front of his office door when a young cop spun on him with a .357 magnum.

"Hold it right there!" he orderd.

"I'm McGuffin, security!" he called, lifting his hands.

A second cop, holding the perpetrator face down on the deck, finished cuffing his hands behind his back, then looked up at McGuffin. "It's okay, he's Sullivan's friend," he informed his partner.

McGuffin dropped his hands as the cop holstered his cannon. He didn't have to ask who the perpetrator was; he recognized the loose Gucci loafer lying on the deck.

"McGuffin, tell 'em who I am!" his landlord ordered.

"We caught him tryin' to bust in," the younger cop said, displaying the screwdriver he had taken from Elmo. "You know him?"

"Of course he knows me, I own the boat!" Elmo shouted.

McGuffin shook his head. "Never saw him before in my life."

"McGuffin!" he wailed.

"The guy who owns this boat claims it has no security," McGuffin said.

"I'm gonna kill you," Elmo said.

"Easy, fella, you're in enough trouble already," the older cop warned. "You want us to book him?"

"If you think it'll save him from a life of crime," McGuffin answered.

"Amos, I'm gonna sue—!"

"Take him in," McGuffin ordered.

"No!" Elmo cried, as the cop pulled him to his feet. "Amos, please tell them—!"

"Tell them what? That you made a mistake, that security aboard the *Queen* is excellent—?"

"Yes, I made a mistake," Elmo admitted.

"And you would like the security officer to remain aboard for as long as he likes?"

"Don't push it, Amos."

"Book him."

"Okay!" Elmo said, when he felt the nudge. "You can stay on for as long as you like."

McGuffin peered closely at his landlord and exclaimed, "Good heavens, it's Elmo!"

The older cop released the cuffs as Shawney O'Sea appeared wide-eyed at the top of the stairs.

"It's all right," McGuffin called, signaling her forward. The younger cop stared at her as she slowly walked over, scarcely noticing the tightly folded twenty McGuffin stuck in his hand. "I'll tell Sullivan you're on the case," he promised.

"Thanks," the young cop said, staring at Shawney.

McGuffin accompanied the cops as far as the top of the stairs, then waved to the tenants clustered below. "It's all right, you can go back inside. Somebody attempted to break into my office while I was away, but you needn't worry, he won't be bothering anyone for a long time." They applauded as McGuffin turned and grinned at Elmo.

"Cute, very cute," Elmo said, rubbing his wrists.

"So is breaking and entering," McGuffin said, pulling the door key from his pocket.

"This is my boat," Elmo protested, as McGuffin brushed past him.

"But it's my office," McGuffin said, as he opened the

door. He waited until Shawney had stepped inside, then turned again on Elmo. "And if you ever again try to break in, I'll have you arrested."

"Aren't you going to introduce me?" Elmo asked.

"No," McGuffin said, and slammed the door on Elmo.

"Does this happen very often?" Shawney asked.

"Too often," McGuffin said, removing his hat and tossing it on the bed. The coat followed. "You can hang yours there," he said, pointing to a hook on the bulkhead behind her.

She removed her Burberry and laid it on the bed beside McGuffin's knock-off. "Nice place," she observed.

"Yeah, quite a change from your father's place on Market Street," McGuffin remarked, as he crossed the cabin to his cluttered desk.

"Market Street—?" she asked. "I seem to remember him being on Post Street."

"You're right, I moved to Market Street after he was killed," McGuffin lied, as he pulled the drawer open. "Funny how the mind plays tricks. Here it is."

"What?"

"The key to the engine room. You wait right here," he said, crossing to the door.

"Can I help?"

"It's not necessary," he said, as he stepped out and closed the door on her.

He was, after all, a hero, and a hero should have no trouble getting someone to help him haul Miles's trunk up to his office. But a few minutes later, after asking in each of the four offices on the main deck, he had no volunteer. May they all be robbed, McGuffin grunted to himself as he pulled the heavy trunk from behind his chicken wire enclosure. It moved easily enough on the steel deck, but when he finally got it to the top of the stairs, he was wet with sweat and breathing heavily.

"My God!" Shawney exclaimed, when McGuffin stag-

gered in ahead of the large old trunk. "You'll kill your-self."

"'s okay," he said, letting one end of the trunk fall heavily to the deck. He sat on the edge of the bed and took several deep breaths while Shawney examined the ribbed, hump-backed trunk.

"This thing must be a hundred years old," she marveled.

"Open it," McGuffin said.

"Can I have the key?"

"It's not locked."

"Not locked?" she asked.

"Don't worry, nothing's been stolen," McGuffin assured her, getting up from the bed. He pulled the rusted hasp away from the empty staple and lifted the lid. "It's all right here where I left it, the files, the souvenirs, the—!" He suddenly stopped pulling things from the trunk and looked up at Shawney with a panicked expression.

"What—?"

"The magical mystery bag!" he said, plunging back into the trunk, slinging files right and left, while Shawney watched with a horrified expression, knowing even before he spoke that "It's gone!"

"No—it can't be," she said, in a tone usually reserved for prayer.

"I don't understand—it was here on Monday," McGuffin said, staring into the nearly empty trunk. "It's been here for eighteen years. Why would somebody steal it now?"

"Isn't that obvious?" Shawney asked. "The egg's been here all the time and you never knew it."

"It wasn't," McGuffin said, shaking his head slowly. "I examined the bag, it wasn't there."

"It must have been," she insisted. "Why else would a burglar run off with a worthless old bag and leave everything else?"

"I don't know!" McGuffin answered, kicking at the files on the floor. He grabbed the back of his neck, paced

the several steps to the far bulkhead and turned. "The only person who's been near this boat in the past three days is Klaus Vandenhof."

"Who's he?" she asked.

"The German officer Kemidov told you about."

She gasped. "It must have been him."

"It couldn't have been. If he had found the egg he wouldn't have stayed around to wait for me. And he'd certainly have no reason to pretend to still need my services. So if it wasn't Vandenhof it must have been Kruger—?"

It can't be, McGuffin said to himself as he reached for the phone. It mustn't be. If he has the egg, Marilyn and Hillary are probably already dead. A woman answered the phone after several rings.

"This is Amos McGuffin. I'd like to speak to Mr. Kruger," he spoke carefully into the phone.

Shawney scarcely moved as she watched and waited. After a long minute, McGuffin spoke again.

"No, I don't have it yet, but I'm getting close," he assured Otto Kruger. "I'm just calling to see if you might know anything about an old leather bag."

"Old leather bag—?" Kruger repeated. "Vut has this to do vit the egg?"

"Nothing at all," McGuffin answered. "I seem to have lost it."

"That is too bad for you."

"You don't know anything about it, huh?"

"No, I do not," he replied impatiently. "And if you are implying that I am a thief—"

"Heaven forbid," McGuffin interrupted. A murderer, yes, a thief, never, he added to himself. "I just thought you might have seen it, that's all. But if you haven't, I'll get on with my search."

"You haf three days, Mr. McGuffin," Kruger warned. Then the phone went dead.

"I know," McGuffin said, as he slowly replaced the receiver.

"Well—?" Shawney asked.

McGuffin shook his head. "It wasn't him." He leaned against the edge of the desk and stared absently at the files at his feet. "And if it wasn't Kruger and it wasn't Vandenhof, who was it?" he asked himself. He looked up at Shawney and asked, "Kemidov?"

"Kemidov—? He's in New York."

"How do you know?" McGuffin asked. "He could have gotten on a plane right after you—or even before. Or if he really is KGB, one of his San Francisco agents could have taken it," he went on, as he reached again for the phone.

"Who are you calling?" she asked, watching as McGuffin dialed information.

"The KGB," he answered.

"You're insane!"

"The consul general, Union of Soviet Socialist Republics, please."

"You can't just pick up the phone and call the KGB!"

"Thanks," McGuffin said, scratching the number on a pad.

"What do you think this is, Russia?" she asked, as he disconnected and dialed again.

McGuffin motioned her to be quiet as the phone was answered by a woman with a slight Russian accent. "This is Amos McGuffin," he informed her. "I understand Mr. Kemidov has recently arrived from New York—may I speak to him, please?"

"Mad," Shawney said, tossing her long red hair back and forth.

After a pause, the woman replied, "One moment, please," and he was put on hold. "*Voilà!*" McGuffin said, covering the mouthpiece. A moment later a male voice, more heavily accented, came on the line. "Who is calling, please?"

"Amos McGuffin for Mr. Kemidov."

"What is this in reference to?"

"Poultry products," McGuffin answered.

"Poultry—?"

"Mr. Kemidov will know what I'm talking about," McGuffin said.

"May I have your phone number?" the Russian asked.

McGuffin recited his number. "Does this mean I'll hear from him?"

"I cannot say," the Russian replied, followed by a dial tone.

"Well—?" Shawney said, as McGuffin replaced the receiver. "Is he here?"

"I'm not sure," McGuffin replied slowly.

"What do you mean—what did they say?" she demanded.

"There may be a Kemidov," he answered. "But if he found the egg in the bottom of that bag, I'm sure he's in Russia by now."

"And if he didn't?"

"If he didn't, I think we'll hear from him."

"But if he does have the egg, that means we're off the hook, doesn't it?" she asked. McGuffin looked at her but said nothing. "I mean there's no reason for him to kill us if he has the egg, is there?"

"No, there's no reason to kill *us*," McGuffin answered.

Her cheerful expression changed to concern. "You don't seem very happy, Mr. McGuffin."

"I'm a pessimist by nature," he explained. "And the name is Amos."

"Amos," she repeated. "Such an unusual name."

"It's short for Ambrose," McGuffin said, a rare admission. He wondered why he had told her, then went on nevertheless, "It means 'belonging to the immortals.' Strange choice for a private eye, huh?"

When she smiled and shook her head, her hair fell again over one eye. "I don't think so."

"I was going to be a lawyer," he said, reaching a hand slowly to the fallen wave, "until I ran into your father."

His fingers brushed her temple as he pushed her fallen hair away. "I loved your father."

She raised her hand to his and pressed it lightly against her cheek. "Yet I have the feeling he disappointed you."

"You were why he did it. There isn't much a father won't do for a daughter. I hope you'll remember that, Shawney."

She nodded and lifted her face to be kissed, like a little girl.

They spent the entire day and a good part of Saturday night poring over Miles Dwindling's files, searching for the clue that would lead to the Fabergé egg, but found nothing. After a quick dinner in North Beach—hurried because the jet lag was suddenly upon her—McGuffin dropped Shawney at her apartment and then swung by Goody's. The place was nearly empty, but Sullivan was there, waiting to escort Goody to his car with the week's take.

"Don't ask," the cop said, before McGuffin could. "That fuckin' girl doesn't exist."

"Perhaps," McGuffin allowed, reaching inside his raincoat, "but these are her fingerprints."

Sullivan watched as the detective carefully unwound a white napkin to reveal a recently used wineglass. "You found her?"

"I won't know for sure until you run these prints through the bureau. Can you do that for me?"

"It'll cost ya," Sullivan said, holding the glass at the edge of the base and turning it slowly in the light.

"Goody, give him a drink on me," McGuffin called.

"I'm closed," Goody snarled.

"He's still pissed at you," Sullivan said, peering closely at a print.

"See any good ones?"

"Several. How come it ain't smeared?"

"She fell asleep after a couple of sips."

"You sleepin' with her?"

"No, but it's not a bad idea," McGuffin answered. "She's beautiful, a New York actress, goes by the name of Shawney O'Sea."

"You serious?" Sullivan asked, placing the glass on the bar. McGuffin nodded. "How'd you find her?"

"She found me. Apparently the Russians are after the egg, too."

"This is turnin' into a fuckin' international incident," Sullivan observed, as Goody, despite his threat, approached with Sullivan's bottle.

Goody slammed the bottle on the bar and demanded irritably, "Whattaya, buyin' your drinks someplace else and bringin' 'em to my joint?"

"No!" McGuffin shouted, as Goody swept the wineglass from the bar and plunged it into the soapy water.

"What the fuck you shoutin' about?" Goody muttered, as he washed Shawney O'Sea's fingerprints from her wineglass.

McGuffin and Sullivan stared dully as the barkeep rinsed and carefully polished the glass with a clean towel, something they had never seen him do before. When he was finally satisfied, he replaced the sparkling glass on the bar and stepped back to admire it. McGuffin turned and walked slowly from the bar.

"Now what did I do?" Goody asked.

The phone was ringing when McGuffin opened the office door. Thinking, hoping that it might be Marilyn, he lunged over the scattered files and snatched the receiver from the desk. "McGuffin!"

"Thank God," Shawney O'Sea said.

"What's wrong?"

"Someone's been here. They tore the place up," she answered.

"Are you all right?"

"Yes—scared, that's all. I've been calling for an hour. I didn't want to call the police until I'd spoken to you."

"No police," McGuffin blurted. "Just stay put, I'll be right over," he said, then hung up the phone.

Shawney O'Sea opened the door as far as the chain would allow, uttered McGuffin's name, then quickly closed and opened it all the way. She surprised him, lunging at him, wrapping her arms tightly against him the moment he cleared the doorway.

"It's okay," McGuffin said, idly stroking her back as he peered over her head at the trashed room. Couches and chairs lay overturned, their bottoms ripped away to expose springs and stuffing, and the floor was littered with the contents of every cabinet and drawer in the apartment. He pried her loose and walked into the living room, gave it a quick glance and went into the bedroom. More of the same, mattress torn open, drawers ripped open and the contents strewn about the room. The chair under the chandelier and the toilet tank lid on the bathroom floor told him that they had searched every cavity in the apartment in search of the Fabergé egg.

Even the china had been taken down from kitchen shelves and spread out on the floor for examination. McGuffin stepped delicately through it, stooped to pick up a Wedgwood bowl and cover, then turned to Shawney, huddled fearfully in the doorway. "Nothing seems to be broken," he remarked.

"Am I supposed to be grateful?" she asked. "I'm sorry," she added, when the detective regarded her with a raised eyebrow. "At first I was only frightened, but now I'm becoming angry and frightened."

"Next comes despondency," McGuffin said. "Then you'll know you're getting over it. Did any of the neighbors hear or see anything that you know?"

"If they did they haven't volunteered it," she answered.

He placed the bowl on the kitchen table, looked around again—he didn't expect to find a clue as to the identity of the burglars, but it would be embarrassing to

overlook a dropped wallet—and walked back into the living room, followed by Shawney. He peered through the bedroom door, at Shawney's empty suitcase and clothes strewn over the torn mattress. "Are any of your things missing?" he asked, turning to her.

She shook her head, knocking her hair down over one eye. "Not even my jewelry—such as it is." She crossed her arms over her chest and rubbed her upper arms as if she were cold. "What does it mean, Amos?"

"It could mean a lot of things," McGuffin answered, removing his raincoat. "It could mean that Vandenhof followed me here this morning, then busted in later, thinking I had passed the egg to you, or you had brought it here for me. Or it could have been Kruger, for the same reason. Or Kemidov," he said, placing his coat over her shoulders. When he tugged it closed, she reached through the opening and squeezed both his hands.

"Is it always so cold here?" she asked.

"Only in the summer," McGuffin answered, peering closely at her violet eyes. He was thinking of one last possibility—that Shawney had trashed her own apartment. No one had seen or heard of the Fabergé egg for more than eighteen years, with the possible exception of Shawney O'Sea. If this were the case, if Miles had gotten the egg to her before he was killed, what would she have done with it? Keep it, a struggling actress, or sell it? And if she was now told by a mad Russian either to produce the egg or be killed, what would she do? Admit that she had once had it, but sold it? Or deny that she had ever seen it and claim that the young PI who was working for her father at the time of its disappearance must have stolen it? And then, to give credibility to her story, to make Kemidov believe that others, too, suspected the PI, she trashed her apartment after their first visit, knowing that Vandenhof or Kruger would be thought responsible. Maybe she was only trying to save her own skin—just as he was only trying to save the lives of his daughter and her mother—and setting him up was the surest way to do it.

Another thought: Maybe Shawney O'Sea isn't Miles Dwindling's daughter, but an imposter hired by Vandenhof, Kruger or Kemidov. Or maybe there is no Kemidov.

His speculations came suddenly to an end when she pressed her lips against his for the second kiss of the day. His coat fell to the floor as her arms went round his neck and she pressed tightly against him.

"Stay with me," she said. "I don't want to be alone."

McGuffin held her away and looked again into those violet eyes. She was afraid of something, he knew. Afraid of being alone, afraid of dying? For some reason, at that moment, she reminded him of Hillary.

"You aren't alone," McGuffin said, tilting his head to kiss her again.

6

By the following morning McGuffin knew that Shawney O'Sea was not innocent. She made love with such a combination of uninhibited passion and intense scholarship that by the end of the night the worldly detective had the feeling that he had experienced a global sex tour with a partner from every race, nationality and erotic creed. "Now what are you doing?" he croaked once shortly after the sun had begun its futile attack on the San Francisco fog. "A Persian love secret, thousands of years old," she responded. "Must have been a very advanced civilization—and a little degenerate," he whispered.

"Wait until we get to the Egyptians."

"I have the feeling I'll be extinct long before then."

They were on the Victorians when the phone rang shortly after eight o'clock. Both of them bolted up, looking for the phone, which was on McGuffin's side of the bed. He picked it up and handed it to Shawney. She

raised it slowly and spoke hesitantly. "Hello—?" Her violet eyes widened as she pressed the phone to her breasts and announced, "It's him! He wants to talk to you!"

"Him—?" McGuffin repeated, reaching for the phone. "Who is this?"

"The name, Mr. McGuffin, is Kemidov. And I am sure Miss O'Sea has told you about me," he replied in slightly accented English.

"Not nearly enough," McGuffin said.

"Then I suggest we meet."

"Why?"

"To discuss the price of eggs—one in particular."

"Where and when?"

"The Russian consulate in one hour?"

"I'll be there."

"Good." There was a smile in the Russian's voice. "Take a cab, Mr. McGuffin. Instruct the driver to leave you off directly in front of the main entrance. Remain there until I come and fetch you. Is that clear?"

"Clear enough," McGuffin answered.

"And come alone," Kemidov added before hanging up.

"Where are you going?" Shawney cried, as McGuffin sprang naked from the bed.

"To the Russian consulate," he answered, striding quickly into the bathroom.

"No! You mustn't go there!" she exclaimed.

Her further protest was muffled by the sound of the shower. She was waiting to go on, however, when McGuffin, a few minutes later, emerged from the bathroom. She was sitting on her haunches atop the bed with a corner of the sheet draped demurely over her lap. McGuffin smiled. It was an ironically modest touch after the events of the night before.

"...and these people are dangerous!" she was saying. "They'll kill you! What—! What's so funny about that?" she blurted, pounding her fist on the mattress.

"I was thinking of something else," McGuffin said, sticking a foot through his pants.

"You haven't heard a word I've said!"

"I heard every word," McGuffin assured her. "They're dangerous and they'll kill me. Most of the time I hear something like that, I turn down the job. But this time I can't," he said, pulling the tie around his neck.

"Of course you can!" she said, jumping up from the bed. "No one's forcing you to go there!"

"I'm afraid they are," he said, watching her in the mirror as he tied his tie.

"Who?"

"A couple of friends of mine," he answered, staring into her reflected wide violet eyes.

"Close friends?"

"Very close."

"You mean—my father and me?" she asked hesitantly.

McGuffin looked at her and nodded slowly. "That's right, you and your father."

"Amos, you're a very sweet man," she said, then put her arms around his neck and kissed him, long and hard. "And I don't want you dead," she murmured against his lips.

"Not to worry, Kemidov is not going to kill me in the Russian consulate and create an international incident. So why don't you just wait right here until I get back and then we'll do that Persian thing again."

"I only do the Persian thing in the dark," she whispered, pressing tightly against him.

He ran his hand down her long lean back and gently slapped her taut behind. "Gotta go."

She released him and McGuffin fled.

The Russian consulate is a six-story mansion occupying about a third of a block in posh Pacific Heights. The main floor is white stucco, with a large pair of mahogany doors front and center bearing a brass plaque announcing that visiting hours are from 9:00 A.M. until noon, Monday

through Friday. The top five floors are of sand-colored brick, graced by many evenly spaced windows across the front, an expression of capitalist greed fallen to the communists, guarded now by a six-foot-high wrought-iron fence, sophisticated detection devices, and several strategically placed Panasonic cameras. On the roof is a small addition that some claim contains microwave spy equipment, although this has never been confirmed.

McGuffin learned much of this from a fetching female cabbie who confessed to really being a writer. "Look!" she pointed, as the cab drew to a halt opposite the gate. "A Reebok-clad, face-lifted, Pacific Heights housewife walking a Russian wolfhound! Do you suppose it's a symbol of international goodwill, or a brazen flaunting of capitalistic-aristocratic privilege?"

"I don't know, but there ought to be at least a short story in it," McGuffin said, exiting the cab in front of the oncoming matron and her wolfhound. She watched as the man in the damp trench coat and misshapen rain hat skipped around the puddles and across the street to the front gate of the Russian consulate, wondering perhaps if he was the communist responsible for the shed on the roof that obstructed her view of the bay.

McGuffin halted in front of the gate and posed for the camera behind the three-inch hole in the mahogany door, first a smiling head-on shot, then a profile of his good side, while wondering what the bureaucrats in Moscow would make of this. When he turned his bad side to the camera he caught sight of the black limousine clearing the steep Green Street hill and turning for him. The car halted abruptly and the rear door was thrown open. "Get in, Mr. McGuffin," a voice from the rear of the car instructed.

McGuffin walked to the car, stooped and peered inside. Mr. Kemidov, wearing the sort of dark twill suit favored by military men on civilian outings, sat stiffly beside the curtained passenger window, his hands resting on a brass-topped walking stick poking up between his knees.

For a man who had to be in his late sixties or even early seventies, he looked remarkably fit, with still thick salt-and-pepper hair cut military style and alert gray eyes above high Slavic cheekbones. He was a man easily pictured standing resolutely before the artillery in the face of oncoming panzers. McGuffin slid past him and settled in the opposite curtained corner as the door was pulled shut and the car raced away from the curb.

"Where are we going?" McGuffin asked.

"For a ride—as they sat in the gangster movies," the Russian answered with a thin smile.

"This is my first ride in a communist limousine," McGuffin observed. It came with all the decadent capitalistic luxuries—moon roof, television, refrigerator, bar and smoked glass all around.

"I hope it won't be your last," Kemidov said.

"So do I, Colonel." Kemidov turned a lazily arched eyebrow on the detective. "It is Colonel, isn't it?" McGuffin asked. "Colonel Kemidov of the KGB?"

"I am sorry to disappoint you, Mr. McGuffin, but it is nothing so—so dramatic as that. I am here as part of a peaceful trade mission, nothing more," he assured the detective.

"What your boys did to Shawney O'Sea's apartment last night was hardly peaceful," McGuffin pointed out.

Kemidov leaned forward on his cane and studied the detective for a moment before replying, "I must say, Mr. McGuffin, even for an American, you are most direct."

"And I must say, lay off her, she doesn't have the egg," McGuffin shot back.

"Then why were you so eager to find her?"

"Because I thought her father might have somehow gotten the egg to her before Kruger killed him, but I was wrong, she doesn't have it. And neither does Klaus Vandenhof or Otto Kruger."

"Then that leaves only you."

"I'm sorry to disappoint you, Colonel, for a couple of reasons, but I don't have it either."

"Then why did you contact Vandenhof, if not to sell him the egg?" the Russian demanded.

"To find Kruger," McGuffin snapped.

"To sell *him* the egg."

"No! To get my..." McGuffin stopped.

"To get your wife and child back," the Russian finished for him.

"How did you know?"

"I know everything that in any way concerns the Fabergé egg," he answered in a quietly assured tone. He laced his fingers over the brass ball at the top of his cane, leaned back in the plush seat and stared straight ahead. They were now driving, McGuffin noticed, through the Presidio military reservation. "I have spent more than fifty years in the service of my government," the Russian agent went on. "Forty of those years have been spent in pursuit of the Fabergé egg—among other things of course," he added with a nod in McGuffin's direction. "My career has been marked by many successes and many honors. By any objective measure, I am a hero to the Russian people, and yet, if I go to my grave without finding and returning the egg to its rightful place in the Kremlin, I will die a failure, disgraced. I tell you this, Mr. McGuffin," he said, nodding again, "because it is so very important to your welfare that you fully appreciate the depth of my vocation."

"I understand, but I'm afraid you don't fully appreciate mine," McGuffin put in. "All you have at stake is your career; I have my daughter, and your threats mean nothing to me because her life is more important than my own. So with all due respect, Colonel, your vocation is nothing more to me than a hobby—like duck carving."

The Russian turned his clear gray eyes on the detective and nodded sadly. "You don't understand, Mr. McGuffin. I am not threatening you, I am threatening your daughter."

"Hillary—! How—how can—?"

"I know where they're being held," he interrupted. "I

waited eighteen years for Kruger's release, expecting him to lead me to the egg, when instead he led me to an abduction."

"Are they all right?" McGuffin blurted.

Kemidov shrugged. "Bored perhaps, but it seems they're being treated well enough."

"I don't suppose you'd tell me where he's keeping them—?"

"I'm afraid not," Kemidov answered. "But rest assured, my people have them under constant surveillance. Whenever it suits me, I can order either their release, or there....But never mind that. I'm only telling you this, Mr. McGuffin, because it occurs to me that we can work together. I believe you when you say you don't have the egg. If you did, I'm sure you would give it to Kruger in exchange for your wife and child, foolish though that would be. Deliver the egg to me, Mr. McGuffin, and I will see to the release of your wife and child. I give you my word as an officer and a gentleman."

"That's the fourth offer I've had this week, Colonel. Why should I throw in with you instead of the others?"

"Because you have no other choice," Kemidov replied easily. "Vandenhof is obsessed with the egg; once he has it he will do nothing to help you obtain the release of your family. And Kruger is unstable; he despises you for sending him to hospital and would gladly kill his hostages once he has the egg." He stopped and looked quizzically at McGuffin. "You say there are three offers besides mine?"

"Shawney O'Sea."

"Ah so, a mistake on my part. Miss O'Sea is no longer a pawn in our game. You and I, Mr. McGuffin, are the only serious players."

McGuffin nodded. "Exactly. When I give you the egg, you'll forget all about my wife and daughter and take the next Aeroflot back to Moscow. Forgive me, Colonel, but I'd rather take my chances with a homicidal maniac than the KGB."

"I said you have no other choice, Mr. McGuffin, and I meant just that. You will either find the egg and deliver it to me and no one else, or I will order the execution of your wife and daughter."

McGuffin looked at the Russian's eyes. They were hard and cold and gray as gun metal. "You're bluffing."

"Then call me. It makes no difference to me one way or the other," the Russian said, shrugging easily. "If you manage to deliver the egg to Kruger, I will simply take it from him—after killing your family. So you see, Mr. McGuffin, it's not American poker we are playing, but Russian chess. And you, sir, are checkmated."

McGuffin glared defiantly at the Russian for a moment, then sighed the sick sigh of defeat. There was little doubt, the KGB was a more formidable foe than Klaus Vandenhof and Otto Kruger combined. "I don't have the egg," he sighed. "I know Miles Dwindling had it, but he must have gotten rid of it sometime before he was killed."

"That is obvious, but what did he do with it?" the Russian asked peevishly.

"I don't know," McGuffin answered testily.

"You must have some idea, you are my last connection to the dead!" he insisted.

"I don't know!" McGuffin shouted. "Unless it was in the black leather bag your men took from my boat."

Kemidov's gray eyes opened wide as artillery muzzles. "I don't know what you are talking about. My men have not been near your boat."

"Somebody was."

"And they stole a leather bag which might have contained the Fabergé egg—?"

"No," McGuffin said, shaking his head. "I examined the bag, I'm sure there was nothing in it. I could have overlooked a written message, or even a key, something like that—but not the egg," he insisted.

"How can you be sure? There might have been a false bottom, or a secret compartment, or—"

"There was nothing like that" McGuffin shouted.

"Then why was the bag stolen?" Kemidov shouted back.

"I don't know—maybe it was just a coincidence! Maybe some kids broke into the boat and walked off with the bag because it was the only thing that wasn't locked up!"

"It wasn't locked?" Kemidov fairly gasped. "The bag may have contained the Fabergé egg and it was just lying about for anyone to come and take? No, no—" he said, bowing and shaking his head. "No one is that big a fool." He slowly raised his head and fixed his gray eyes on the detective. "And least of all me, Mr. McGuffin."

"What do you mean?" McGuffin asked.

"I begin to see that I may have overestimated your familial fealty. You would like to have your daughter back, but you would also like to keep the egg if that is possible."

"I told you, I don't have the egg," McGuffin replied in a firm voice.

"And I believed you—until you went too far. Until Kruger alerted you, you did not know the egg existed. Then when you searched for it, you found it in the leather bag. What have you done with that bag?" he demanded.

"I don't have it," McGuffin answered calmly.

Kemidov stared evenly at the detective for several seconds as the limousine wound leisurely through the Presidio. He removed his hand from the cane and showed McGuffin his open palm. "I hold the life of your daughter in my hand, Mr. McGuffin. Shall I give her to you? Or would you rather I—?" he asked. His gray eyes turned to slits and the muscles in his cheeks twitched as he clenched his fist into a hard tight knot.

McGuffin watched as the face returned, twitching occasionally, to its original composure. "If you harm either one of them, your career will be a failure. You'll die in disgrace, but sooner than you think," he warned in a slow but steadily cadenced voice.

Kemidov laughed softly. "You have forty-eight hours to deliver the egg. After that," he said, drawing a card from his breast pocket, "your wife and child will be no more. When you are ready to comply, you will phone this number for instructions."

McGuffin took the card, upon which was printed a single phone number and nothing more. "It may take more time," he said, slipping the card into the pocket of his raincoat.

"Forty-eight hours," he repeated. "Where would you like to be dropped?"

"Shawney O'Sea's apartment. It's on—"

"I know the address," Kemidov interrupted, reaching for the intercom. He gave directions in Russian—the only word McGuffin understood was Leavenworth—then the driver made a squealing U-turn in front of the military cemetery and headed for Shawney's apartment on Russian Hill.

Shawney had the apartment and herself neatly back in order by the time McGuffin returned. She threw her arms around him and squeezed him tightly when he stepped into the room. "Are you all right?" she asked.

"He never laid a glove on me," McGuffin replied, as he peeled her off. He missed the couch with his hat, found it with the raincoat, remembered the card and transferred it to his jacket pocket.

"What does he want?" she asked, following a few steps after him, then stopping near the center of the room.

"The same thing everybody wants," McGuffin said, turning to look at her. She wore a white sweater with padded shoulders and sharply pressed gray slacks, and her red hair had fallen again over one eye. She clutched one fist in front of her and leaned slightly forward, both eager and fearful to hear what happened. "If I don't come up with the egg in forty-eight hours, he says he'll kill my wife and daughter."

"Wife—?"

"Ex-," McGuffin added.

"You didn't tell me—"

"There are a couple of things I didn't tell you. Sit down," he said, indicating the couch, "and I'll tell you everything."

Shawney sat on the edge of the couch, hands and knees pressed tightly together, and listened while McGuffin paced and told her everything that had happened, beginning with the discovery of Marilyn and Hillary's abduction and concluding with his limousine ride through the Presidio.

"Then you never intended to help me?" she asked, looking up at McGuffin, her violet eyes now open wide.

"I intended to help you," he corrected. "But it had to be my way. I meant to deliver the egg to Kruger in exchange for my wife and daughter, but I also intended to see that no harm came to you from Kemidov."

"How?" she cried. "How could you possibly protect me from the KGB?"

"I'm not certain that he is KGB," McGuffin answered, hooking a hand over the back of his neck.

"Not certain—?" she repeated. "You phoned the consulate."

"And they neither confirmed nor denied that he was one of them."

"But he phoned you here. How would he have gotten this number except from the Russian consulate?"

"All he had to do was look up this address in the reverse phone directory. Or he could have gotten it from whoever broke in here," the detective explained.

"But he met you at the consulate," she protested, shaking her head helplessly at the detective's obstinacy.

"But I never actually saw him inside. It's true his car came from the direction of the parking compound at the rear of the building, but again I didn't actually see it come out of the gate," he mused, beginning again to pace, hand

over the back of his neck. "But it wasn't just that—it's more a feeling I had."

"Feeling—?"

"It was something about his performance. I had the feeling I was watching a stage Russian, if you know what I mean," he said, swinging around to face her when he reached the wall.

"I know exactly what you mean," she said. "But take it from an actress who once did *The Cherry Orchard* for an entire summer in the Berkshires, the man who interrogated me in New York is no stage Russian, he's the real thing." She shuddered, remembering, then got up and walked across the room to the detective. "Don't think I don't appreciate it, Amos, because I do, honestly. But I know as well as you that Kemidov is KGB and that my life is in danger." She put her arms around his neck. "You're a nice man, but a terrible liar," she said as she lifted her lips to his.

McGuffin returned the light kiss, then grasped her padded shoulders and held her at arm's length. "You're no longer in any danger," he said. "As long as Kemidov thinks I have the egg, the only people in any danger are my daughter and ex-wife. You can go back to New York whenever you like."

She brushed the hair from over her eye and looked closely at McGuffin. "Is she really your *ex*-wife?"

"Yeah, we're divorced," he nodded.

"Then I think I'll stay."

7

They sat at a table next to the window in a Columbus Avenue coffee shop, eating a late breakfast and watching sullen San Franciscans passing back and forth in the rain. This was the seventh straight day of it and the collective nerves of the city's population were becoming frazzled. Autoists honked at little provocation, domestic violence was up, tans were fading and Herb Caen hadn't been funny in days. Shawney O'Sea stirred her coffee and stared through the rain-streaked window.

"When will it end?" she asked.

"When we have the egg," McGuffin answered.

"I mean the rain."

"Soon. Everything has to end sooner or later—books, movies, life, the world—"

"My, my," she said, as she raised her coffee cup.

McGuffin stroked his chin—he hadn't shaved in

nearly two days—and turned his eyes on her. "I've been thinking about secret compartments."

"You think it was in the bag?"

"I hope not," McGuffin answered, shaking his head wearily. "Because if it was, it's now in the hands of a stranger and it's unlikely that any of us will ever see it again. I was thinking about the possibility of a secret compartment somewhere in your father's office."

"Wouldn't you have known if there were?" she asked as she replaced her cup on the saucer.

"There were a lot of things I didn't know about your father," he answered. "He was the kind of man who favored secret recesses. But the office was just one small room—not even a closet—and a few pieces of furniture. I took the bookcase with me when I moved to Sansome Street, I'm sure there was nothing there. And I must have searched the desk thoroughly."

"You don't remember?" she asked.

"I was settling his affairs, not searching for a million-dollar jewel," he replied peevishly. The missing bag was chafe enough.

"What happened to the desk?" she went on, heedless to the effect of her implied criticism.

"I left it there."

"No—," she whispered.

"It was ugly—your father used to let his cigars burn out on it!" he protested.

"Do you think it might still be there?"

"Shawney, it was a worthless pile of scorched oak," he explained patiently.

"It can't hurt to look," she said, quickly dabbing at her lips with her napkin. "Waiter!"

"Shit," McGuffin said, reaching for his wallet.

McGuffin hadn't been back to the old building on Post Street in more than sixteen years. Aside from the name on the formerly bare frosted glass of room 308, Thad-

deus Thane, Certified Public Accountant, things looked the same.

"This is dumb," McGuffin said.

"Knock," she ordered.

McGuffin knocked and a moment later the door swung open, revealing a short fat man with rolled sleeves and a long cigar. "Mr. Thane?"

Thane stared curiously, first at McGuffin then at Shawney—it was obvious he didn't get much business off the street—before replying, "Yeah?"

"My name is Amos McGuffin, I'm a private investigator."

"Thane's not here!" the little man cried and tried to close the door.

"I'm not a process server!" McGuffin called, planting himself firmly against the door.

"This was my father's office, I'm looking for something of sentimental value," Shawney quickly added.

"Don't give me that shit," he grunted, struggling to close the door. "I been here sixteen years!"

"Then you must know Miles Dwindling—the guy who was here before you," McGuffin muttered through a clenched jaw. The little accountant was stronger than he looked.

"The guy who was shot?"

The pressure against the door was relieved. "Right. I worked for him at the time."

Thaddeus Thane pulled the door back, took two deep breaths and asked, "So what's it got to do with me?"

"He may have left something in his office when he died," McGuffin said, peering over the little man's bald head. The office looked much the same as it had, except for the mismatched filing cabinets that lined the walls. And the desk, partially concealed by cartons and mounds of papers, seemed to be oak.

"Whattaya, kidding—I been here sixteen years, I never seen nothin'."

"This was very small, a piece of jewelry," Shawney said.

"Jewelry—?" he asked, eyes alight.

"Nothing of any value," McGuffin said quickly. "It was his wedding ring. His daughter is getting married and she'd like to have it."

"Her?" he asked, pointing an ink-stained finger at Shawney. "You're gettin' married?" Shawney smiled and nodded vigorously. "You talked to your accountant about this?" he asked.

"Accountant—?"

"She doesn't have an accountant—yet," McGuffin said.

"No accountant?" he asked. "Because there can be serious tax consequences. Everybody should have an accountant."

"He's right," McGuffin said. "Especially somebody in Bruce's tax bracket."

"Lotta money?" Thane asked.

"Scads," McGuffin answered.

"Let me give you my card," he said, then turned and walked to the desk.

McGuffin and Shawney followed him in. While Thane looked for his card, McGuffin edged over to the corner of the desk and lifted a pile of papers. Under the papers was a row of cigar burns. "This is it," McGuffin said.

"What—? Hey, those are confidential papers!" Thane shouted, lunging across them.

"We don't want to look at your papers," McGuffin assured him. "We just want to have a look inside this desk."

"There is no ring in this desk," Thane said firmly. "I should know, I been usin' it for sixteen years."

"There may be a secret compartment," McGuffin said.

"Secret compartment—? I think you been readin' too many spy books."

"My father was fond of such things," Shawney explained. "And if I'm right, I'll be happy to pay you for your time."

"How much?" Thane asked.

"Five hundred dollars," McGuffin said.

"I thought Bruce was rich," the accountant reminded him.

"That's true," McGuffin said. "But Bruce wants her to wear his mother's ring, so he won't contribute to this." Thane glanced skeptically from one to the other.

"I think I can go to a thousand," Shawney said.

Thane continued to search their faces. "This is legit, you ain't from the IRS or somethin'?"

"Mr. Thane, if we were IRS we'd come in with a subpoena rather than waste time like this, wouldn't we?"

Thane considered for a moment, then nodded. "Okay, but you don't look at none of my papers. I catch you lookin' at the papers and the deal's off."

"Thanks," McGuffin said, going for the drawers.

He pulled the middle drawer out completely, examined it quickly and handed it to Shawney. Thane watched closely as the detective and the bride-to-be pulled all seven drawers from the desk and piled them on the floor. Tapping noises issued from beneath the desk until, a few minutes later, the detective emerged.

"Yes?" the bride-to-be asked.

"No," the detective answered.

Thane waited while they replaced the drawers, then followed them to the door. "Have Bruce give me a call," he said, handing his card to Shawney.

"Sure," Shawney said. She dropped the card in the ashtray as they waited for the elevator.

When the security officer of the *Oakland Queen* walked down the main deck with Shawney O'Sea, all of the architects looked up from their glass-walled bins, and one even walked to the doorway to watch her climb the stairs. It was a hopeful sign, McGuffin thought, that men responsi-

ble for some of the ugliest buildings in San Francisco could still appreciate classic beauty.

He opened the door to his office and stepped in ahead of Shawney, clearing a path with his feet as he slogged across the cabin, still cluttered with the files from her father's trunk.

"I'll clean this up while you shower and shave," she volunteered, watching from the doorway as papers flew.

"You don't have to do that," McGuffin said, as Miles's basketball trophy clattered across the deck.

"Really, I'd rather," she said, hurrying across the cabin after it.

McGuffin shrugged. "Okay, I'll help you."

"It isn't necessary, take your shower," she said, carrying the trophy to the trunk.

McGuffin watched as she carefully placed her father's trophy in the bottom of the trunk, then knelt down and began gathering files in her arm. After a moment he knelt opposite her and began picking up files. "I'm sorry I kicked your father's stuff around like that," he said.

"It's all right," she replied. "I was hoping my father's bag might magically appear under all this mess."

"Lay off me about that bag, will you?" McGuffin pleaded, settling back on his heels.

"Sorry."

"And give me the bird," he pointed.

"I'll give you the bird," she replied, as she reached for the tin crow.

McGuffin took it between his chin and the files, then got to his feet and walked to the trunk. He stood poised to drop everything in the trunk, then froze.

"What's the matter?" Shawney asked.

"What you just said, it reminded me of your father's last words. I thought he said, 'He's out of his bird.' But maybe it only sounded like that. Maybe he really said, '...out of the bird,' or '...in the bird'!"

Shawney came off the deck like a cat, grabbed the tin

crow and howled. "It's sharp!" she said, shaking a cut finger.

"I'll get a bandage," McGuffin offered.

"Never mind, open it!" she ordered, thrusting the bird at McGuffin.

McGuffin carried the crow to his desk, Shawney on his heels. She watched, torn finger in her mouth, as he pried at the seam with a letter opener. He managed to force the point in about an inch, but when he began to twist, the opener snapped in two pieces.

"Shit!"

"A screwdriver!" she said.

"I don't have one."

"Butter knife—?"

"Only plastic."

"Bachelors," she muttered, looking about the office. "What do you have?"

McGuffin, too, looked about the cabin until he remembered. "A shoehorn!"

Shawney shot him an exasperated glance, then continued to look about the room for a makeshift tool while McGuffin went to the chart drawer for a metal shoehorn. When he found it and managed to force it into the seam of the bird, her exasperated expression gave way to a dubious one; and when the crow popped suddenly apart, revealing a nest of matted straw, changed once again to a look of breathless anticipation.

"It must be," she said softly, watching, heedless of the blood dripping from her finger, while McGuffin carefully pulled the straw away to reveal. . . .

"The Fabergé egg," he announced dully.

They gazed silently at the jeweled egg lying on a bed of straw inside a crib made from half a tin crow from Tijuana, unable as yet to comprehend fully their discovery. It was, even to the detective to whom it represented two lives, an undeniably exquisite jewel, approximately the size of his tightly clenched fist. And although untouched for more than eighteen years, each perfect

golden eagle still shimmered, as if about to fly from the opaque white enamel, filigreed by silver and platinum twisting among rubies and sapphires. Even the pedestal, the Russian imperial shield carved from blue-black porphyry and set with gold, diamonds and pearls, was by itself a jewel fit for a museum.

McGuffin lifted it reverently from the straw, like a priest raising the monstrance, and held it up for Shawney's inspection, turning it slowly in the lamplight so that each stone and gold facet radiated with a colored light that merged in an unreal glow. Framed in each of the imperial Russian eagles could be seen the tiny but perfect likeness of each of the Romanoff czars.

"How incredibly beautiful," she said.

"And ingenious," McGuffin added, searching for the lever that would open the egg. When he found it on the bottom of the pedestal and moved it, the seemingly seamless egg opened like a flower, revealing a globe with two maps of the Russian empire inset in gold, one inscribed 1613, the other 1913.

"What do you intend to do with it?" Shawney asked, her voice no longer coming from beside him. When McGuffin turned, he saw her standing in the open doorway, her hand in her purse.

"I intend to trade it for two innocent lives," McGuffin said, watching as she slowly withdrew her hand from her purse, revealing a white handkerchief. He sighed audibly when she wrapped the handkerchief around her cut finger.

"Is something wrong?" she asked.

"No, nothing," he answered quickly. He turned and walked to the desk, placed the egg beside the phone and lifted the receiver. "I'm going to leave you with a friend of mine, a cop named Sullivan, so you won't have to worry about Kemidov. Then I'll phone Kruger and arrange for the exchange."

"What about Vandenhof?" she asked.

"I'll worry about him later," he said as he dialed

Goody's number where Sullivan would be at the cocktail hour.

"I should worry now if I were you," a familiar voice warned.

McGuffin snapped around to see Vandenhof's large frame filling the doorway, the Luger in his hand. He pushed Shawney aside and stepped inside, followed by Toby, a new gun in hand, bigger than the Beretta in McGuffin's coat pocket. He pulled the door closed as Vandenhof ordered, "Hang up the phone." McGuffin heard Goody's voice a moment before hanging up. "Now stand away from the desk," the fat man ordered, fanning the air with the Luger.

McGuffin moved to one side as Vandenhof crossed the room, hungrily eyeing the Fabergé egg atop the desk. His hand shook as he reached for it and raised it slowly to within a few inches of his fervid eyes and licked his fat lips, as if he were getting ready to swallow it. His shallow breathing became audible, resembling a chuckle, until he gasped suddenly, almost orgasmically, "Beauty, you are mine!"

McGuffin was sickened. "What about our deal?" he asked, knowing it was futile.

"Our deal—?" Vandenhof repeated, followed by a short laugh. "Required that you deliver the egg to me, not Otto. You betrayed me, Mr. McGuffin. Not that it matters," he added, chortling softly, "for I never had any intention to help you obtain the release of your wife and child once I had the egg. So let's say we are even," he proposed, snapping a white silk handkerchief from his breast pocket while clutching the egg in the same hand. He spread the handkerchief out on the desk, placed the egg in the center, folded the corners over it and dropped it into the side pocket of his jacket.

McGuffin was looking for an opportunity to jump for the gun and Toby saw it. "Go ahead, beat the bullet," the gunman urged.

"Amos, don't—!" Shawney pleaded.

"Toby, dear, be patient," Vandenhof soothed as he waddled back to his place beside the door.

McGuffin's chances of beating two guns were about a hundred to one, but his and Shawney's chances of living if he did nothing were nil, he now knew. "If you think you're going to kill us and walk away, there's something you'd better know," he began, talking fast. "This boat is under constant police surveillance. The cops saw you come aboard, they know who you are. You might kill us before they get here, but you'll never get off the boat."

"I'm afraid the surveillance is not exactly constant, Mr. McGuffin. They come by every half hour, which gives Toby," he said, glancing at his watch, "about twenty-four minutes to kill you. You won't require any more time than that, will you, Toby?"

"It'll take about a millionth of a second," Toby replied.

"It won't work, there are people in the offices downstairs," McGuffin tried.

Vandenhof shook his head. "They're all gone for the day."

"But why kill us? You've got the egg, take it and go," McGuffin urged.

"I only wish it were that easy," Vandenhof said with a sad face. "Some men can forget, if not entirely forgive, a betrayal—even if it means the loss of one's wife and child. Others, the Elie Wiesels of this world, can never forget. Injury, imagined or otherwise, renders such men forever indifferent to self, impervious to comfort, beauty, wealth or any of the other opiates that an otherwise harsh society might provide a certain privileged few. And you, Mr. McGuffin, although you would have me think otherwise, are an avenger."

"I prefer to think of it as justice," McGuffin said.

"While I must think of survival," Vandenhof countered. "If I allow you to live, you will not allow me to live. Please, don't deny it."

"I'm not, I just want to know how you got the egg in the first place before I'm killed for it."

"It was given to me in exchange for a trainload of Jews," Vandenhof answered, shrugging easily.

"Yeah, I thought it was something like that," McGuffin said. "And the Jews, were they saved?"

The fat man chuckled. "One trainload of Jews for a Fabergé egg—? Surely you are not serious."

"You're right, Vandenhof, you have to kill me."

"You are most understanding, sir."

"But not her."

"I will take care of her," Vandenhof said, taking Shawney by the arm. When she cried Amos's name, the fat man yanked her to the door. "Now I'm afraid Toby must get on with his business before your friends return." He opened the door and pulled Shawney through the hatchway after him, stopping and turning for a final shot. "I must say, Mr. McGuffin, even though you won't be needing any more references, that I found your services most satisfactory. Thank you, sir, and good-bye."

"Amos!" Shawney cried again as Vandenhof slammed the door.

McGuffin turned from the door to Toby.

"I thought this day would never come," the executioner said.

"You aren't that dumb, are you, Toby?"

"Just keep up with the insults, McGuffin, so I won't feel bad taking you down piece by piece," Toby said, shifting the big automatic from hand to hand.

"He's setting you up to take the fall. Why else do you think he removed himself from the scene?" McGuffin argued desperately. "If I'm killed the cops will come straight for you and Vandenhof—they know all about you."

"Knowing is one thing, proving is another," Toby replied, unmoved by McGuffin's brief.

"No," McGuffin said, shaking his head, "that's not the way it'll be. These guys are friends of mine, they won't bother with the legal niceties. These guys will go to work

on the two of you, and when they do, one of you will crack. And you know who that'll be, don't you, Toby?"

"Nobody will crack," Toby replied confidently. "But keep it up, I like to see you squirm."

"Your boyfriend will crack," McGuffin predicted. "They won't beat him with a rubber hose like they will you. No, he'll get the velvet glove treatment. In exchange for testifying against you, they'll let the fat man walk. You'll go to the gas chamber and your boyfriend won't even come to your funeral."

"You know what you are, McGuffin? You're a homophobe. You think people like us are fickle and unreliable. You can't understand that the love of one man for another can be every bit as good and lasting as the love between a man and a woman. Klaus loves me. He'd never do anything to hurt me," Toby insisted.

"He loved Otto Kruger, too," McGuffin reminded him. "But he threw him over for somebody younger and prettier. Why shouldn't he do the same to you when the time comes? Especially if it means staying out of jail. Wise up, Toby. Kill me and within six months you'll be on death row, and Vandenhof will have a new young boyfriend."

"Shut up!" Toby shouted, thrusting the gun to within a few feet of McGuffin's face. "You don't know what you're talking about! Klaus can't testify against me because I know where the bodies are buried! Don't think you're the first! He's killed before—over things a lot less valuable than an egg! And besides—besides, I know what Klaus did in the war!" he went on, gun and eyes dancing jerkily.

Come a little closer, McGuffin said to himself, watching as the gunman struggled to regain control. There was a thin line between awareness and abuse and McGuffin knew he was dangerously close to stepping over it. Back off, talk about Klaus for a while. "What did he do in the war?" McGuffin asked softly.

"He—he sent thousands of Jews to the camps. First

in Holland, then in France. But first he stole everything they had. Klaus made millions on the war. So even though I may be getting a little older, I guarantee you, McGuffin, he'll always prefer me to the Israelis."

"That doesn't change things," McGuffin insisted, knowing full well that it did. "He'll still have to save his own skin first from the district attorney and for that he'll have to give them you."

"Enough!" Toby cried suddenly. He raised the gun until McGuffin could see into the bore, then pulled the hammer back until it fell into position with a solid click. "I'd like to stay and watch you crawl, but I've got to go before your friends come around again. You understand."

The shot followed only a moment later, a split second after the detective, knowing that at that moment he presented the smallest target, had jerked his head to one side and lunged blindly forward. Their bodies collided vaguely—McGuffin's head struck something that crunched and gave as he groped blindly for something to grab and hold on to, preferably a gun. Someone cried out, a second shot was fired and McGuffin felt himself falling blindly, out of control, until he was stopped by something soft. He was lying on top of the struggling Toby, he realized after a moment, and the gun lay across the deck beside the trunk. When Toby's knee found McGuffin's groin, he grunted painfully and rolled off the smaller man, then scrabbled after him, racing crabs, McGuffin by a claw.

He found the gun and rolled onto one side as Toby appeared above him. The automatic jumped once in his hand and Toby fell like a shot bird across McGuffin's legs. Keeping the gun at the ready, he extricated himself and climbed to his feet. When he slipped a toe under Toby's shoulder and flipped him over on his back, he saw what had crunched against his head. Toby's formerly aristrocratic nose was now lying over to one side like a mongrel's ear, and although it had been discharging blood prodi-

giously only a moment before, now it was still, its pump stopped by .45-caliber slug.

"I knew it couldn't last," McGuffin said, as he slid the warm automatic into his jacket pocket. Until now he had been in the PI business for eighteen years without killing anyone.

It's difficult to find a cab in the rain during the dinner hour in San Francisco, even if it's a matter of life and death. It was a few minutes after eight when McGuffin's cab pulled to a stop in front of Shawney O'Sea's temporary quarters on Leavenworth Street. He stepped out, unmindful of the rain, dug under his trench coat for a twenty and passed it through the driver's window.

"In case you haven't noticed, Mac, your head is bleeding," the driver informed McGuffin as he passed him his change.

McGuffin touched his forehead and came away with blood. "It's not mine."

"So whose is it, Mac?" he asked, waiting for his tip.

"The guy I just killed," McGuffin answered, pocketing the tip. He hated guys who called him Mac.

"Very funny," the driver said uncertainly, then stomped on the pedal.

McGuffin turned his face to the rain and looked up at the ugly green fortress on the side of the hill. A pale yellow light glowed dimly from behind the lace curtains on the first floor, but that didn't mean anyone was there, he knew, as the desk lamp was always on. He removed a handkerchief from his breast pocket and wiped Toby's blood from his face, snagging the cotton material in his beard. It was Monday evening and he hadn't shaved since Saturday morning, he realized, as he started up the stairs to Shawney's apartment.

The front door was closed and singly locked, but the detective managed to open it easily with a plastic card. He removed Toby's Beretta from his coat pocket, suddenly aware that he was now carrying two guns, both of them

Toby's, then slipped quickly into the dimly lighted foyer. The only light in the living room came from the reading lamp on the desk near the window, and seated at the desk with a startled look on his face was Klaus Vandenhof.

"Keep your hands on the desk where I can see them," McGuffin ordered, stepping quickly into the room behind the sweeping Beretta. "Where is she?"

Vandenhof said nothing.

"Did you kill her?" McGuffin demanded.

"No," Vandenhof replied. "She killed me."

It was only then that McGuffin saw the dull stain spreading slowly under Vandenhof's lapel where, under layers of fat, his heart should approximately lie. The hole was scarcely visible, no wider than the silver pen clutched in the fat hand resting next to an open checkbook. McGuffin walked to the desk and picked up the checkbook. It was made out to Brigid LeBlanc in the amount of $10,000 and signed by Vandenhof.

"Who's Brigid LeBlanc?"

"I am. Don't turn around or I'll shoot!" the woman whom McGuffin had until now known as Shawney O'Sea/ Ivey Dwindling barked sharply. "Place the gun on the edge of the desk and step away slowly." McGuffin did as instructed. "Good. Now turn around with your hands in the air. And please don't do anything foolish, Amos," she said as he raised his hands and turned. She had a small silver automatic pointed at his chest, the kind favored by women who have learned the hard way that karate was never meant to be a coed sport. "Killing Klaus was a public service. You I wouldn't enjoy. Open your raincoat and let it fall to the floor."

"I'm not in the habit of carrying two guns, if that's what you're thinking," McGuffin said as he unbuttoned his coat and let it fall softly to the floor. He waited for the order to remove his jacket, but it didn't come.

"I told Klaus you'd be too much for Toby, but he didn't believe me," she said, brushing the hair from over her eye.

"So that was the reason for the victim act," McGuffin guessed.

"Exactly. Even if you survived Toby, I expected to be in South America by the time you learned Klaus hadn't killed me. But now you've messed up my plans, Amos. I don't know what to do."

"Why not throw in with me?" McGuffin suggested.

"Seriously—?" she asked, amused.

"Seriously. Let me have the egg long enough to get Marilyn and Hillary, then I'll take it back from Kruger and give it to you. You'll be free to go. I'll never bother you again, I give you my word," he pleaded.

"What about Kemidov?" she asked.

"He's a lousy actor, forget him," McGuffin advised.

She laughed shortly. "So you saw through that one, did you?"

"I wasn't certain of anything then, but now it's reasonably clear," McGuffin answered. "I made the mistake of telling Vandenhof the little I knew about Miles Dwindling's daughter, so he hired an impersonator to keep an eye on me. I must say, you're a better actor than Kemidov. I was suspicious at first, but when you came out with that high school identification in the name of Ivey Dwindling, I tumbled."

She smiled, obviously pleased with herself. "That was my idea. Klaus had the card made up. He was very good at forgery and art swindles and things like that, poor dear," she said, glancing his way. The blood had spread over his entire shirt front and his face was ashen. If he was not already dead, he soon would be, McGuffin guessed. "Harold—that's Kemidov—and I worked with Klaus several times. We were usually the aristocratic but destitute refugees who had to sell off the family collection to one of Klaus's rich but dumb customers. It seemed a lark at first—Harold and I are both serious but penniless New York actors, or at least I *was*, he still is—but lately it's become absolutely dangerous!" she exclaimed, wide-eyed. "That's why I decided to retire—with the Fabergé egg, of

course. But I'm so happy that my last performance was so utterly true and convincing!"

"Good sex dulls my faculties. And you were good, Brigid, you were very good," McGuffin assured her.

"I prefer Shawney, it's my stage name. And although I don't expect you to believe it, Amos, I wasn't entirely acting," she said, allowing her hair to fall over her eye. McGuffin wondered which of them she used to sight her gun. "I really do like you."

"Then trust me."

"Darling, I wish I could, I really do. But what would we do about him?" she asked, waving the gun in Vandenhof's direction, then quickly back to McGuffin. "My God, I'm a murderess! Or soon will be," she added, peering closely at her victim's eyes. "It sounds terribly dramatic, doesn't it—Shawney O'Sea, Murderess?"

"I've got that figured out," McGuffin said, glancing at Vandenhof. He had slumped in his chair, his chin rested on rolls of fat and both hands hung limply at his sides, while the blood that had collected on the wooden chair was now beginning to drip onto the carpet. "I take it this is Vandenhof's apartment."

"How did you know?"

"I recognized his taste. And it was hard to believe that the KGB could trash this place without breaking even a single piece of Wedgwood china."

"Did you hear that, Klaus!" she scolded, before turning to McGuffin. "I told him—"

"Let me tell you how you can beat the homicide rap," McGuffin interrupted.

"Yes, do. How can I possibly avoid that except by getting out of the country?" she asked quickly.

"We lay it on Toby," McGuffin answered.

"Toby—? Didn't you kill him?"

"That's the beauty of it," McGuffin answered, nodding vigorously. "With just one corpse we clean up both your mess and my mess at the same time. I'll bring Toby here. We'll put your gun in Toby's hand and Toby's gun in

Vandenhof's hand. The cops will be happy. They'll have two corpses and two murderers, already tried and executed," he said, talking with and lowering his hands at the same time. His right hand was only a few inches from Toby's bulky automatic in his jacket pocket. It was only the fact that his tweed suits customarily served as briefcase and filing cabinet that she wasn't alert to the possibility of a second gun, but at the moment he made his move she'd be on to him, he knew. Do I risk it now, or do I count on her buying the Toby plan?

"I didn't tell you you could put your hands down," she reminded him, but gently.

"Sorry," McGuffin said, raising them halfheartedly. She was considering it. "Listen to me, Shawney, you've got to do this my way, not just for my sake, but for your sake as well," he went on in a quick urgent voice. "If you kill me and walk out of here with the Fabergé egg, you'll have the FBI, Interpol and every government in the world after you. Cops don't like unexplained corpses, Shawney. Give them Toby and the case will be closed."

She smiled as she considered this, then suddenly smiled and asked brightly, "Why can't I give them you?"

"Me—?"

"Sure. You broke in, Vandenhof shot you and you shot him. It's all very neat and tidy."

"But what about Toby? You've got an extra corpse."

"You shot him before you came here—just as it really happened," she said with a reasonable shrug.

"It won't work," McGuffin said, shaking his head. "I told the cops all about you and the egg. I delivered a set of your fingerprints to the FBI. If they haven't got a make on you by now they soon will."

"Amos, you're lying," she said playfully. "My performance had you totally convinced."

McGuffin shook his head. "Not totally. The night we had dinner, when you were falling asleep at the table, I took your wineglass and gave it to my friend Sullivan, a

cop," he said, ending his story at the place just before Goody washes the glass.

"You bastard," she said softly, disappointed in either her performance or McGuffin.

"So you see you've got to do it my way, Shawney. Otherwise the cops will be after you for the rest of your life—which won't be very long. Kill me and they'll nail you for all three murders, as well as grand larceny. Do it my way and you'll live to enjoy your money."

"But the FBI knows about me," she said, trouble showing in her face for the first time.

"It won't matter," McGuffin assured her. "I'm your alibi and you're mine. We were miles away when the murders took place and we never found the egg."

She studied him closely from behind her fallen hair, then brushed it back and asked, "And after you have your wife and daughter, you'd give me the egg—you wouldn't want even a small piece for yourself?"

McGuffin shook his head. "Nothing."

"You know, I believe you, Amos," she said slowly. "I think you're just enough of a Boy Scout to turn your back on ten million dollars, once you've given your word."

"Thanks," McGuffin said, showing her his altar boy smile and lowering his hands.

"Keep them up!" she ordered.

"But why?" he asked, lazily raising them.

"Because I could never trust a Boy Scout," she answered. "Money means nothing to you—if it did you wouldn't be a private investigator. But morality and justice and things like that, that's what matters to you, Amos. You could allow me the egg, but you could never allow my murder to go unpunished," she said as she raised the gun and pointed it directly at McGuffin's chest.

McGuffin was about to speak, to desperately attempt to convince her that he was just as amoral as the next guy, but he never got the chance. He heard the explosion and felt the slug and watched as Shawney O'Sea was snatched from the carpet and slammed against the wall by an un-

seen force. It took a moment to realize that the explosion had come not from Shawney's tiny automatic but from behind him. He turned to see Vandenhof, ashen and dull, taking feeble aim for a second shot from the small but lethal Beretta McGuffin had left on the desk.

McGuffin stood transfixed, equally amazed that Vandenhof was alive and he himself would soon be dead. He saw the slug hurtling for him in a gush of red, then knew, all in the space of a split-second frozen in time, that it was not lead but blood, spewing from the mouth of a man who was dead when his head hit the desk. And the slug that had struck him, he realized when he saw the tear in his jacket pocket, had glanced off Toby's gun and struck Shawney, somewhere in the vicinity of her beautiful breasts, he guessed, seeing the blood slowly covering the front of her white sweater.

She looked up at him with the eyes of a trapped but resigned animal, still breathing, and asked, "Is it bad?"

McGuffin took two steps toward her and looked down. The hole was very close to her heart. "Not bad," he lied.

"I wasn't going to kill you," she lied.

"I know," McGuffin lied.

Then she was dead. McGuffin walked across the room to the desk, picked up the phone and dialed Goody's number. Judge Brennan picked up on the third ring and McGuffin asked to talk to Sullivan.

"Where the fuck you been, I got her!" Sully blurted.

"Who?"

"Ivey Dwindling, only it ain't Dwindling, it's Sinaloo or some fuckin' thing which means 'inner peace' or some bullshit like that and she's livin' in a fuckin' commune in fuckin' Oregon and if you want her you gotta go get her."

"I can't," McGuffin answered.

"And if you're anywhere near that broad Shawney O'Sea you better get the fuck away from her because I got some news on her, too," Sullivan went on. "She's an art swindler, twice arrested but never prosecuted 'cuz one of the pigeons wouldn't testify and the other couldn't fly."

"What do you mean?"

"He fell out of a window in New York. So watch yourself, McGuffin, she may be a killer."

"She is," McGuffin said.

"You got proof?"

"I'm standing next to it—Klaus Vandenhof."

"No shit! I was just comin' to him."

"Let me guess," McGuffin interrupted. "He's her partner, along with another actor named Harold. She and Harold pretend to be rich aristocrats who have to sell off the family—"

"Don't tell me you bought a painting," Sullivan interrupted.

"This time it was an egg. I got it all over my face."

"What the fuck are you talkin' about?"

"I've got the egg. I'm on my way to make a trade for Marilyn and Hillary. I'm just calling to report a murder."

"Right, the broad killed Vandenhof—"

"And Vandenhof killed her," McGuffin added.

There was a pause from the usually unflappable police officer. "If this catches on I'm gonna be out of a job. Where are you?" McGuffin gave him the address. "You're sure you had nothin' to do with this, huh, Amos?"

"Not this one," McGuffin answered.

"There's another one?"

"You'll also find a body on my boat."

There was a second pause. "You know, McGuffin, you're turnin' into a regular fuckin' cadaver supply house. What's with this one?"

"I'll tell you about it later," McGuffin promised.

"Whattaya mean later! You can't go around leavin' all those corpses lyin' around!" Sullivan hollered as McGuffin pressed the disconnect bar.

He fished in his pocket for the number, found it and dialed. A man answered. McGuffin identified himself and asked to speak to Otto Kruger. A few moments later, Kruger picked up.

"Do you haf it?" he demanded.

"Yeah, I've got it," McGuffin answered.

"Vunderful!" the little German exclaimed. "Ven vill you deliver it?"

"Not so fast," McGuffin said. "How do I know that they're still alive?"

"How do I know that you haf the egg?"

"I'm prepared to prove it."

"How?"

"I'll show you a photograph of it."

"That proves nothing, Klaus could haf given you a photograph."

"Not very likely," McGuffin said, glancing down at the dead man. "But just so you'll be sure, I'll make it a nice, shiny, new Polaroid, with a copy of today's *Chronicle* thrown in. After that I want to speak to Marilyn and Hillary on the phone. Then when I'm satisfied that they're alive, I'll tell you how the exchange is to take place. Do you understand?"

"Perfectly."

"Good," McGuffin said, looking at his watch. "I'm leaving now, I should be at your place within a couple of hours. Just one more thing—"

"Yes—?"

"I won't have the egg with me, just a picture, so don't send your boys to intercept me or do something foolish like that, okay? Because if you kill me, you've killed the goose that lays the golden egg."

"You can trust me," Kruger answered.

"Yeah," McGuffin said as he lowered the phone to the cradle.

He found the Fabergé egg in Shawney's half-packed bag, still wrapped in Vandenhof's white silk handkerchief. He slipped it into the left pocket of his tweed jacket, drew the belt of his raincoat tightly around his waist, then walked out into the wet San Francisco night. He was stepping into a cab at the corner of Union and Leavenworth when the first prowl car rounded the corner with siren wailing and lights flashing. McGuffin ordered the driver

to take him first to a newsstand, then to a penny arcade off Market Street. At the first stop he bought the day's *Chronicle*, and at the second he leaned over the front seat and said, "Keep the meter running, I'll be back in five minutes."

Before he could protest, the man in the wet coat, badly in need of a shave, had disappeared into the seedy crowd surrounding the entry to the arcade. The driver was sure he had been stiffed, but he waited until, a few minutes later, his fare returned, minus the newspaper, and ordered him to Executive Rent-A-Car on Van Ness Avenue.

"Sure," the driver said, wondering who would rent a car to a bum like that.

8

Under normal circumstances McGuffin would have driven his own car to the Hauptmann Vineyards, but with the homicide squad swarming all over his boat and a probable APB out on him by now, the circumstances were scarcely usual. So McGuffin drove to St. Helena in an anonymous beige Plymouth, wiper blades gliding rhythmically back and forth against the steady rain. On the seat beside him were three small photos of McGuffin's hands holding the Fabergé egg next to the day's *Chronicle,* scarcely high art but sufficient to the task. In the left pocket of his brown tweed jacket rested the real thing. He patted it reassuringly from time to time as he drove through the blackness. He didn't think Otto would risk the loss of the egg by sending his goons to intercept him—assuming he had hostages to trade for it—but if the madman had murdered them and had nothing to trade, then he knew anything could happen.

When a car fell in behind him as he approached Napa, he removed Toby's automatic from his jacket and placed it beside the photos. When he pushed the Plymouth to eighty and the trailing car disappeared in the rearview mirror, he slowed the car and replaced the gun in his pocket. Everything's going to be fine, McGuffin told himself, as the lights of Napa came into view. The phone call proves they're still alive—or were then. And why would Kruger kill them now, when the egg is about to be his? McGuffin asked himself. Because he's a madman, he answered. Everything's going to be fine, he again reassured himself.

McGuffin drove slowly around the town square, past gift shops, restaurants, inns and hotels, until he came to a relatively large hotel announcing a vacancy. He parked in front of the building, then stepped out into the drizzle and hurried inside. The elderly man behind the high wooden desk, alone in the lobby, watched somewhat apprehensively as the man with the stubble of beard hurried toward him, both hands deep in his wet trench coat. Here clearly was a man with a purpose, good or bad.

"I'd like a room," the man said, removing a hand and stroking his beard, as if to acknowledge an unusual condition.

When he failed to wince at the steep tourist's price, the old man decided he must be all right. He took a key down from the board while his guest filled out the registration card.

"I'd also like a large manila envelope, some tissue paper and a roll of tape. Do you think you could find that?" McGuffin asked, digging into his pocket and coming out with a roll of bills.

"Of course, Mr.—Andrews," the clerk said, reading upside down from the registration card, a professional skill long acquired. He disappeared into the office behind the desk and emerged a few minutes later with everything Mr. Andrews had requested.

McGuffin pushed a twenty across the desk, picked up

his purchase and went to his room on the third floor. When he returned, scarcely fifteen minutes later, he placed the sealed envelope containing a bulky object atop the desk along with another twenty.

"I'd like you to check this for me," McGuffin told the clerk.

"Of course, Mr. Andrews," the clerk said, reaching under the desk for a plastic disk with the number 13 printed on it.

"Could you give me another number?" McGuffin asked. The old man smiled condescendingly and produced number 14. "And if I haven't come back to pick it up by checkout time tomorrow, I want you to mail it—it's already addressed."

"I'll do that," the old man promised, as he palmed his second twenty of the night.

The clerk waited until his generous guest had walked out of the hotel and into the rain, then looked at the face of the envelope. It was addressed to Goody's Bar and Grill in San Francisco. He felt the object in the envelope, round and smooth beneath the tissue and tape, and wondered what it might be. It felt like one of those glass balls that snow when you shake them, but why anybody would want to spend forty bucks to send a piece of junk like that to San Francisco was beyond him.

Past the Old Bale Mill beyond St. Helena, McGuffin slowed the car and peered through the shafts of wet gray light for the peeling sign that marked the gravel road to the Hauptmann Vineyards. He saw it too late, skidded to a stop and backed up to the gravel road. A dull light poked out from the library and the kitchen, but the upper floors of the castle were dark. Definitely not a warming sight, McGuffin decided, as he braked in front of the house. When he thrust the photographs into his shirt pocket, his fingers brushed against the plastic claim check. He removed the number 14 chip, stared indeci-

sively at it for a moment, then stuffed it into the ashtray under a pile of butts.

A porch light came on as McGuffin stepped out of the car. He pulled his hat brim down and walked quickly up the puddled path as the front door opened for him, revealing Hans Hauptmann, Jr., and Schatze the wonder dog.

"Have a nice trip, Mr. McGuffin?" Hans asked, as the detective climbed the few steps to the porch. The dog was quiet but attentive.

"Where is he?" McGuffin demanded, brushing past the young man.

Ahead of him, Karl stepped into the foyer and motioned in the direction of the library with a .45 automatic. "In here," he ordered.

"I thought this was supposed to be a peaceful transaction," McGuffin said as he stepped into the library.

"It is just a precaution." Otto Kruger spoke from behind the desk in the shadowed room. The only light came from the green shaded desk lamp meant for writing but lately used for interrogation. "You haf brought the egg?"

"I told you I wasn't bringing it," McGuffin answered, as he reached into his shirt pocket for the photographs of the same.

"Then you won't mind if Karl searches your car," he said, motioning to the young man. "Search it thoroughly," he called, as Karl pocketed his gun and left the room, only to be replaced by Hans and Schatze. "And you won't mind if Hans searches you," the pie-faced man added.

"As a matter of fact I do," McGuffin said. Schatze growled menacingly when McGuffin pushed Hans's hands aside and walked quickly across the room, flushing Kruger out of his chair, a snub-nosed revolver in hand. "Relax," McGuffin said, tossing the photos on the desk. "I told you I was bringing proof that I have the egg and I have. Now I want proof that Marilyn and Hillary are alive and well."

"And so you shall, Mr. McGuffin," Kruger murmured as he peered bug-eyed at the photographs. "Yes,

yes—this is it—the Fabergé egg," he said, the excitement building in his voice. "How I haf wanted it. Now everything vill be like it vas." His face was aglow with excitement as he turned to McGuffin. "But I still must search you. Raise your hands," he ordered, thrusting the gun at McGuffin.

"Shit," McGuffin muttered, as he lazily lifted his hands.

Hans patted him down, quickly and inefficiently, but managed to find Toby's automatic in his jacket pocket.

"I thought this vas to be a peaceful transaction," Kruger observed as Hans placed the gun on the desk.

"Just a precaution," McGuffin replied. "Now let me talk to my daughter."

Kruger shook his head slowly. "That is not possible."

"What—! I told you there'd be no exchange until I talked to them, and you agreed!" McGuffin charged.

"I said I understood, I did not agree," Kruger replied.

"Don't play word games with me, Kruger! You do and you'll never see the egg, I promise!"

Kruger shrugged easily. "Then you vill never see your vife and daughter."

"You've killed them," McGuffin said weakly.

"I haf not killed them. I haf moved them to a place close by vit no phone. All you haf to do is gif me the egg and I vill bring them to you."

McGuffin shook his head. "And all you have to do is deliver them to Goody's bar in San Francisco. When I know they're there, I'll give you the egg."

"You must forgive me, Mr. McGuffin, but I don't believe any man vuld valk away so easily from several million dollars."

"Then a mutual exchange on neutral ground," McGuffin suggested.

"Vut neutral ground?"

"The town square in Napa."

Kruger considered for a moment, then asked, "Vut assurance do I haf that the police vill not be vaiting?"

"I'll stay here until your hostages are in place. Then we'll leave together and we'll all meet in the center of the square where the exchange will take place."

Kruger fixed his fish eyes on the detective and blinked as he asked, "How vill you get the egg?"

"I'll tell you that when the time comes."

"It's in the car!" Kruger exclaimed triumphantly. He picked up Toby's .45 as he rounded the desk and handed it to Hans. "Vatch him," he ordered.

"It's not in the car," McGuffin said wearily, as Kruger hurried from the room. "Shit—" He dropped into the leather chair beside the desk and looked up at Hans, awkwardly pointing the gun at him. "Don't point that thing at me, Hans, it might go off."

"Sorry," the blond youth said, turning the gun away from McGuffin.

"What's in this for you, Hans? A couple of thousand dollars? Ten percent of whatever the egg brings?"

Hans shook his head. "Half."

"Half," McGuffin repeated, nodding appreciatively. "Not bad. But are you sure you can trust a homicidal maniac?"

"Otto is no homicidal maniac. What he did was for love. But I don't expect you to understand."

"Ah, I see," McGuffin said, waving his finger back and forth. "You and Karl are—"

"Lovers? Yes, Karl is my lover."

"And the little old man upstairs, your father—? How does he feel about all this?"

"His son is gay and it's okay," Hans answered.

"I'm not talking about the buggery, Hans, I'm talking about the kidnapping. How does he feel about his kid going to prison for twenty years?"

"Shut up," Hans said, turning the gun back to McGuffin.

"You cooperate with me and I'll testify for you when

153

the time comes," McGuffin proposed. "Just tell me where he's keeping them, that's all I want to know."

Hans shook his head. "Don't ask, I can't tell you."

"Hans, I'm talking about the difference between a suspended sentence and ten or fifteen hard years. Just tell me where they are," McGuffin urged, talking quickly.

"I can't, I'm sorry!" Hans blurted. "Please, leave me alone."

In a minute he would talk, McGuffin was sure. But at that moment Kruger returned, wet and angry as a washed dog.

"Vut is this?" he demanded, waving a fist in the air as he crossed the room. He slammed the plastic disk on the desk and stood back, hands on hips. "Vell—?"

McGuffin got up, walked to the desk and pretended to see the claim check for the first time. Until now he had thought fourteen his lucky number. "Poker chip?"

"This is no poker chip, Mr. McGuffin. This is a claim receipt and Karl found it in the ashtray of your car."

McGuffin shrugged. "It's not my car. If you look in the glove compartment you'll see the rental papers. This must have been left by the last person who had the car."

"I think not. I think this is the receipt for the Fabergé egg and I think you checked it someplace near the town square. The bus station perhaps, or a hotel. Vich is it, Mr. McGuffin?"

McGuffin tried to look bored. "You'll have to ask the guy who rented the car before me."

"I haf the right man," Kruger replied, quietly confident. "I believe you are an honest man, Mr. McGuffin. Ven you tell me you vill exchange the egg for my hostages on the town square, you mean to do just that. Once you see your vife and daughter on the square vit Karl, you vuld go into the hotel on the square vhere you haf checked the egg, and you vuld return vit it, and you vuld hand it over in exchange for them. That vas your plan, vas it not, Mr. McGuffin?" he asked, excitement dancing in his fish eyes.

"No, that's not my plan," McGuffin lied. The dog snorted.

"There is no need to deny it," Kruger went on cheerfully. "Your plan is perfectly acceptable to me."

McGuffin turned to the beaming pie-faced man. He was holding the white disk between thumb and forefinger, just inches from McGuffin's face, a priest about to place the Eucharist on his tongue. Slowly, McGuffin lifted his hand. When he took the disk between his own thumb and fingers, the German's face went suddenly hard and he snatched the disk from McGuffin's grasp.

"So, I vas right," he said. "Your vell-laid plans haf come to nothing." Schatze lay on the rug, gazing admiringly at the little German as he paced about the room, tapping the disk in his hand. "If only you had trusted me, Mr. McGuffin, you vuld now be on your vay back to San Francisco vit your vife and daughter."

"Even if you find the egg, they won't release it to anyone but me, I've taken care of that," McGuffin warned.

"So much distrust," Kruger said, turning a sad face to the detective. "Vy can't ve just be friends?"

"You're right, I'm afraid I'm guilty of letting little things interfere with our relationship," McGuffin admitted.

"That's better." He flipped the disk across the room and McGuffin caught it with one hand. "You see how easy it is?" McGuffin said nothing as he dropped the disk into the pocket of his damp coat. "Now ve can make the exchange just as you suggested, on neutral ground. Get our coats, vuld you?" he asked, turning to Hans. Hans nodded and disappeared through the doorway, followed by Schatze. "Karl vill bring your vife and daughter to the square, vile Hans vill drive us to the hotel," he went on, motioning McGuffin through the doorway ahead of him. "From now on, buddy," he said, laying a hand on McGuffin's shoulder and falling in step beside him, "everything vill be strictly kosher."

"Jesus—!" McGuffin breathed, when he stepped onto the lighted porch and saw his rented car. All four doors were lying open, as well as the hood and trunk lid; the headliner hung in shreds from the ceiling, and the torn seats were lying on the grass, soaking up the falling rain.

"Don't vorry, buddy," Kruger said, taking McGuffin by the elbow and steering him down the stairs, "I'll pay for the car—once I haf the egg. You can stop, Karl!" he called, as Karl ripped away a piece of dashboard. "You go vit Hans to the car vile I talk to Karl," he said, giving McGuffin a nudge in the direction of the barn.

McGuffin glanced back once as he and Hans splashed through puddles to the barn. His buddy was engaged in purposeful conversation concerning the disposition of his ex-wife and daughter. He waited while Hans unlocked the barn door and rolled it back. The grape wagon, McGuffin saw when Hans switched on the light, was still in the same place.

"Would you close the door after I've pulled the car out?" Hans called as he walked toward the back of the large barn.

"Good idea," McGuffin said, starting for the cart. He waited until Hans was getting into the car, then climbed quietly over the side and dropped into the wagon. He found his gun in the corner of the wagon where he had thrown it in his haste to escape from Schatze, grape-stained but operable. He slipped it into his coat pocket with the claim check and climbed quickly out of the wagon, a moment before Hans backed the big Mercedes out of the barn. While McGuffin was pulling the heavy door closed, he saw Karl drive off alone in a station wagon, presumably to pick up Marilyn and Hillary. Everything's going to be all right, McGuffin told himself as he walked through the slanting gray rain to the idling Mercedes. He slid into the front seat and Hans rolled the big sedan around to the front of the house where Kruger

"Your head," the woman pointed. "Can I help you?"

McGuffin touched the blood-caked handkerchief and shook his head. "I'm fine." The bleeding had stopped, along with the double vision, and the ache had greatly subsided. "Where would he go?" McGuffin asked. He didn't know if the question was to them or to himself.

"Who?" the cook asked.

"Otto—he means Otto," Hauptmann answered. "He is supposed to remain here—those were the conditions for his parole. I should not have agreed. It was bad for Hans, all this talk of money. I agreed because he was an old friend, a countryman, but I think he is not a good man anymore."

"What talk of money?" McGuffin asked. "Ransom?"

The old man shook his head. "A jewel. Hans said Otto would make him a millionaire. Why? When I die he will be a millionaire. I never should have let Otto come here. I should have made Klaus take him."

"Klaus Vandenhof—? I don't think that would have worked," McGuffin said. "Vandenhof threw him out a long time ago."

"It doesn't matter, Otto still loved him—like a woman loves a man."

"Otto told you that?" McGuffin asked, climbing quickly to his feet.

"Many times. Sometimes, after too much wine, he would talk about Klaus and tears would come to his eyes," the old man said, looking to the cook who confirmed with a nod.

McGuffin stared incredulously from one to the other, as Otto Kruger's words came back to him: "Now everything vill be like it vas." Why hadn't he seen it? Because he was a homophobe, as Toby had claimed? Probably— because had it been heterosexual love, such a possibility would have figured in the equation from the outset.

"Where's the phone?" McGuffin demanded.

"There is one in the kitchen," the cook pointed.

McGuffin raced down the stairs, found the wall

stood waiting beside the wrecked rental car. Hans stopped and Kruger got into the backseat.

"You vill tell Hans how to go," he instructed, as Hans pulled the car away.

"Just drive to the square," McGuffin said. From the top of the drive he was able to glimpse the station wagon turning left onto the road below, only a moment before it disappeared around the turn. "I assume Karl has gone for the hostages," McGuffin said.

"Everything has been taken care of," Kruger assured him, as Hans negotiated the twisting drive.

The drive was not a long one, but Hans drove cautiously over the rain-slick road that twisted along the valley floor past darkened vineyards, and it was nearly half an hour before the town appeared, glowing dully through the lead-gray rain. Hans drove wordlessly to the north end of the square, then glanced questioningly at McGuffin.

"Right," McGuffin said. "Then left at the corner."

Hans did as directed and the big Mercedes rolled slowly along the edge of the square, past the few lighted inns and hotels still open. The hotel where the Fabergé egg resided, lying diagonally across the corner of the square, was down to a single light above the front door.

"Park here," McGuffin instructed.

Hans parked diagonally, facing the park. The headlights reached briefly through the rain, across the park to the buildings opposite, then went out. McGuffin twisted around to the rear of the car and spoke to Kruger.

"Where are they?"

"They should be here shortly," Kruger answered, glancing at his watch. "Vhere is the egg?"

"I'll get it after I've seen them."

"Ven Karl arrives, he vill flash his lights twice. That is the signal that he has them."

"Not to me it isn't," McGuffin replied. "I'm not moving until I see them standing outside the car."

"Karl already has his instructions. They cannot be countermanded," Kruger informed him tersely. "Ven you

give the egg to Hans, Karl vill release them. In the meantime, if you even attempt to move toward them before I haf the egg, Karl vill immediately execute his hostages. And you," he added.

"That wasn't our deal!" McGuffin protested.

"I'm sorry, they are my only insurance. I cannot take the chance that you vill escape vit the hostages and the egg." He reached forward and patted McGuffin on the arm. "Don't vorry, Mr. McGuffin. You keep your part of the bargain and I'll keep mine. Ve are buddies now."

"If we're such good buddies, why don't you tell Hans to give me back my gun?" McGuffin suggested.

Kruger smiled. "Ve are not yet such good buddies as that." As he spoke, headlights flashed twice from the end of the square opposite the hotel where the egg rested. "They haf arrived," Kruger said, pointing left through the wet windshield.

McGuffin peered through the rain across the dark square. He could barely make out the dark station wagon, glistening wetly in the last edge of light from a wind-tossed street lamp, and he could see none of its occupants.

"Listen carefully, Mr. McGuffin," Kruger ordered. "The lives of you and your family depend on you following my instructions exactly. You and Hans vill go together to get the egg. Ven you haf it, you and Hans vill valk to the center of the square. Karl vill proceed at the same time from the opposite side of the square vit your vife and daughter. Ven you meet in the center of the square, you vill give the egg to Karl and he will surrender his hostages to you. Is that clear?"

"Yeah, that's clear," McGuffin answered.

"And remember, Mr. McGuffin, there vill be three guns trained on you at all times," he warned as McGuffin opened the car door.

"That's hard to forget," McGuffin said, then slammed the car door.

He pulled his hat down against the pelting rain, then stuck his hands deep in his coat pockets, wrapping one

around the claim check and the other around his grape-stained automatic. Kruger and Hans were locked in conversation inside the closed car, but McGuffin could hear only the rain beating on the roof and hood. A few moments later Hans stepped out of the car and the two men started in the direction of the hotel.

"What was that all about?" McGuffin asked.

"He told me to shoot you if you tried anything," Hans replied impassively as they turned at the corner.

McGuffin studied the profile of the blond youth as they continued to the hotel. Yeah, he'd do it, he decided. He stopped in front of the hotel and motioned with his chin. "This is it."

"After you," Hans said, motioning with the gun in his raincoat pocket. "I'll be right behind you."

McGuffin said nothing as he climbed the few steps to the porch and opened the front door. The clerk was napping lightly behind the desk, so McGuffin hit the bell. The old man snapped to his feet with the practiced efficiency that comes from working nights. "Good evening," he said, glancing from the still unshaven Mr. Andrews to the clean-shaven youth standing a few steps behind him. "Something I can do for you?"

"Yeah, you can give me my package," McGuffin said, laying the number 14 disk on the counter.

"Certainly," the old man said, and retreated to the office behind. He emerged a few moments later with the manila envelope which he placed on the counter. He watched as Mr. Andrews folded the envelope tightly around the ball inside and stuffed it into the left pocket of his soaked trench coat. Then he turned and walked wordlessly out of the lobby, followed by the effeminate young man. Never would have guessed Mr. Andrews was one of them, the old man said to himself as he went back to his nap.

Hans hurried to catch up as McGuffin walked across the street, and side by side the two men stepped out onto the village green. Their shoes made squishy sounds

on the wet turf, until McGuffin stopped. "I don't see anybody coming," McGuffin said.

"Keep walking, they'll come," Hans assured him.

McGuffin proceeded another twenty yards and still there was no movement from the opposite side of the square. When he stopped again, Hans prodded him with the gun. "Keep walking."

"What's he done with them?" McGuffin demanded.

"Walk!" Hans ordered, pulling the gun from his pocket.

"He's killed them!" McGuffin said, walking backwards toward the center of the square. "Tell me, goddamn you, tell me!"

Suddenly the headlights from the Mercedes flashed on, followed by the station wagon, catching McGuffin in the crosslight. "Where are they?" he shouted, shading his eyes with his left hand, trying to see behind the lights.

"Does he haf it?" Kruger called from McGuffin's left.

"Yes!" Hans replied.

"Get it!"

"No!" McGuffin shouted, as Hans extended his free hand for the Fabergé egg.

The 9mm slug passed through McGuffin's trench coat and Hans's open hand before striking Hans in the sternum and slamming him to the ground.

"Karl, shoot!" Kruger called, as McGuffin spun and dropped to one knee.

McGuffin heard a shot, felt or imagined it passing close to his head, and searched desperately for a target in the blinding light. There was a second shot and the sound of feet splashing for him, then a dark silhouette as Karl appeared in the field of light. He fired once and the dark form kept coming. McGuffin's shouted curse and the sound of another shot, this from his left, echoed through the streets of the little town as the gun twitched and Karl appeared, hurtling through the air in a suicidal dive, falling heavily to the ground and sliding across the wet grass to within several yards of his executioner.

Or so McGuffin thought until he saw the head come off the grass, followed by the gun. He fired once more, putting a small hole in the front of Karl's skull and a much larger one in back.

Then he swung to his left like a revolving artillery piece, to where Kruger waited in the dark, as another explosion rang in his ears and something wet and heavy thudded against his face. The explosion continued to echo as he hurtled through a dark void, clutching a piece of damp turf that had been torn from the earth, twisting and spinning while something, death perhaps, pulled at his coattails, pulling him down to the depths of hell. Then he smelled the wet grass and felt a searing pain, as if he were pinned to the ground by a lance driven through his brain.

Fighting the pain (something told him he must), he got to his hands and knees and surveyed the battlefield. He saw two lifeless bodies—no, Hans was alive—and three guns. He picked up his own, and his rain hat and got to his feet. He became aware of lights flashing on around the perimeter of the square and the murmur of puzzled voices.

He touched the pain in his brain and came away with blood on his fingertips, then saw the hole in his battered rain hat. Hans was trying to speak—or was he speaking but McGuffin couldn't hear?—and the Mercedes had disappeared. McGuffin patted his now empty pocket, placed the hat on his bleeding head and staggered across the square in the direction of the still beaming headlights of the dark station wagon.

The residents of the town stood on porches or in open windows, but no one made an attempt to stop the gunman lurching across the green to the car at the edge of the town square. The gunman glanced into the backseat, seemed to stifle an anguished cry, then stumbled into the front seat. He started the car, backed it up somewhat unsteadily, then swung it in a wide turn and wove hesitantly down the street and out of town.

Slowly the onlookers came down from their porches and out onto the square to gather around the two bodies sprawled in the mud. A few minutes later a siren wailed and a police car with flashing lights bounced over the curb and across the square. Now even more townspeople, no longer afraid of bullets or rain, streamed out onto the square to see what had happened.

Only the old hotel clerk knew for sure. To him it was a fag killing, plain and simple. Mr. Andrews had left the hotel with the clean-shaven youth, then had a run-in with the lad's boyfriend, and nobody could tell him any different. Hell, he could tell from the look in that bearded man's eye that he was nobody to mess around with, homo or no homo.

9

Closing one eye, McGuffin discovered as he drove uncertainly back to the Hauptmann Vineyards, eliminated his double vision, but nothing could stop the throbbing pain. It was like being drunk and having a hangover all at the same time. The bleeding seemed to have stopped, stanched by the handkerchief he had managed to stuff under his hatband with one hand while steering wobbily with the other. Never knew drunk driving could be educational, McGuffin said to himself as he turned off 128 and started up the twisting drive to the darkened house at the top of the hill.

The eviscerated rental car was where it had been, its parts strewn over the lawn, but there was as yet no sign of the Mercedes—although it could be behind the closed barn door, McGuffin realized. But just in case Kruger hadn't yet arrived, he pulled the station wagon around to the back of the house and parked beside a pickup truck. He lifted the still warm gun from the seat beside him,

opened the door and stepped out into the dark wet court-yard.

There was no warning from the stealthy hunter other than the rhythmic splashing, like a horse on a sloppy track, until suddenly she appeared out of the darkness, fangs bared, racing for the intruder's throat. It seemed for a moment like a slow motion movie, Rin Tin Tin charging through the silver rain on a mission of mercy, until two sharp bursts from McGuffin's gun, of which he was scarcely aware, abruptly destroyed the illusion. Schatze died as Karl had died, hurtling through the air, then falling heavily to the ground and sliding across the wet grass to within a few feet of McGuffin. He stood poised to pump another bullet into the animal, but Schatze was a dead dog.

"Good dog," McGuffin said, as he stepped over her and started to the back door. Light flashed from the up-stairs window, fixing a dull, rain-laced spotlight on the place McGuffin had stood a moment before.

Finding the kitchen door locked, McGuffin shattered a section of mullioned glass with the butt of the Smith & Wesson, then reached in and turned the knob. Staying low, gun ready, he lunged into the kitchen, then held and waited. A few moments later a light appeared in the doorway across the room, revealing a flight of carpeted stairs.

"Hans—?" a thin apprehensive voice called from up-stairs.

"Mr. Hauptmann?" McGuffin called, moving cau-tiously toward the light.

"Yes—who is there?"

"A friend, don't be alarmed. Who else is in the house?"

"Just the cook."

"Come to the top of the stairs," McGuffin ordered.

Moments later a frightened old man in striped pa-jamas appeared at the top of the stairs. "Where is Kruger?" McGuffin asked, as he climbed the stairs.

The old man shook his head. "They haven't come back."

"What about my wife and daughter, where are they?" McGuffin barked, peering down the corridor in both directions. The cook stood at one end of the corridor, partially visible in the doorway. "Where is he keeping them?" he shouted to the cook.

"We know nothing about that," the woman replied.

"Don't lie to me!" McGuffin shouted. "I'm running out of patience!"

"Please, she is telling the truth," the old man said. "I know my son and Otto are up to something—something bad, but we don't know what. We know nothing about your wife and daughter, believe me."

"I'm gonna tear this place apart, old man, and if I find them it's going to be very hard on you! Do you understand?"

The old man nodded. "You won't find them. We don't know where they are."

"Goddamnit!" McGuffin wailed, then threw open the first door he came to. The bedroom was neatly made up, ready for any guest that might drop in, but there were no guests in sight. McGuffin went up and down the corridor, finding the same thing in each room. The bedrooms on the third floor, too, were void of occupants, but none of these rooms was made up, and some were being used for storage. Hauptmann and the cook were waiting at the foot of the stairs when McGuffin returned. He sat on the stair and rested his head in his hands, the gun pointing to the ceiling.

"We heard shots," the old man said.

"I had to kill the dog."

"Good," the cook said.

Hauptmann didn't correct her. Instead he asked, "Is my son in any trouble?"

The detective took his hands away from his face and looked up at the old man's watery blue eyes. "I don't think so."

phone and quickly dialed. "Be there, be there," he murmured as he paced—then blurted, "Goody, it's Amos!"

"McGuffin, where the hell are you? No, don't tell me! Did you kill all those people?"

"I'll tell you about it later. Is Sullivan there?"

" 'Course he ain't here, he's out lookin' for you, like every other cop in San Francisco. He told me to tell you to come in, Amos. And get a lawyer—not O'Brian, a Jewish lawyer—'cuz you're in deep shit, Amos."

"I'm coming in, but not just yet," McGuffin replied. "In the meantime I need a favor."

"Anything."

"Get Sullivan down there and keep him there until you hear from me. I'm going after Marilyn and Hillary and I may need some help."

"Bring Sullivan here, right," he repeated.

"Thanks," McGuffin said, and hung up before Goody could reply.

He nearly bowled the cook over as he pushed past her and hurried down the hall to the front door. He fitted the front cushion back into the rented car, then jammed the rear cushion in haphazardly, followed by the door panels and dashboard section. Then he closed the hood and trunk, got in and started the engine on the third attempt. He tore the dangling strips of headliner from in front of his face as he slipped and slid down the drive before going into a skidding turn onto 128 and heading south. He glanced at the digital clock in the remaining section of dashboard. It was almost midnight. Kruger was possibly there already.

10

The dark Mercedes was parked in front of Vandenhof's house when McGuffin drove up in his tattered rental car. He got quickly out of the car, hunched down against the rain and made a dash for the front porch. The door was unlocked, an amber light seeped down the stairs into the foyer. McGuffin flattened himself against the doorpost and pushed the door open with the muzzle of his automatic. "Otto?" he called, doing a passable imitation of the late Klaus Vandenhof.

"Klaus, is that you?" Kruger called from the source of the amber light, somewhere upstairs.

"Yes," McGuffin answered, as he stepped quickly inside.

"Is Toby vit you?"

"No," McGuffin answered, stepping onto the first carpeted stair.

"Good. I hope you're not angry that I came, Klaus."

"No," McGuffin answered, taking the next stair.

"I haf brought you a gift, Klaus—a most vonderful gift. Something you vant more than anything in the vorld. I am sorry for vut came between us, Klaus—so sorry," he went on in a breathless, high-pitched voice, as McGuffin continued to climb the stairs. "But ven you see vut I haf brought you, everything vill be vonderful again, Klaus, I promise. Everything vill be just as it vas. Vhere are you, Klaus—are you coming?"

"Yes."

"I am here, in our old room, the room vhere ve made love so often before. Hurry, Klaus. I vant to see your face ven you see vut I haf brought—you!" he exclaimed, seeing the detective in the doorway.

Otto Kruger, wearing only a blue silk kimono, sat atop a darker blue bedspread, propped up on one arm, feet tucked up under him, trying to look seductive. A dull light bathed the antique-strewn room in a pinkish haze that lent the Fabergé egg, carefully arranged in the center of the bed, a smoldering golden hue. His jaw worked wordlessly as the detective walked across the room and snatched the egg from the bed.

"...dead," he managed, pointing at McGuffin.

"That was somebody else," McGuffin said, pointing the automatic directly between the old man's bulging round eyes. "And you're about to join him if you don't tell me what you've done with Marilyn and Hillary. Talk!"

"You vill ruin everything!" he shouted suddenly, eyes bulging madly. "Give me the egg! Klaus vill be here at any minute!" The old man climbed to his knees, clutching the kimono around him with one hand while reaching for the egg with the other. "Please."

McGuffin slid the egg into his coat pocket, then slowly raised the gun until it was pointed directly between Otto Kruger's pleading eyes. "I've gone as far as I can," McGuffin breathed wearily. "You murdered my boss, you kidnapped my little girl and her mother, you violated our agreement and you caused me to kill three people. Now tell me where they are before I make it four."

"Three people!"

"What?"

"You killed three people. Hans and Karl—who vas the other?"

"Toby," McGuffin answered.

The old man's eyes grew still wider as he stared at the detective and shook his head slowly. "No—," he whispered, settling back on his haunches, pushed by an invisible force. "He's not coming—? Klaus—is dead?"

"I didn't kill Klaus," McGuffin said.

"Who?" he asked, tears welling in his eyes.

McGuffin hesitated, then replied, "A woman."

"Woman—?"

"A business associate."

"Klaus is dead," Kruger said, as if speaking to a small child. A tear fell from one bulging eye and coursed down his cheek. He smacked his lips and clenched his hands in a tight ball, then pulled them apart, as if releasing a bird in the room. "It vas all for nothing."

"What—what was all for nothing?" McGuffin asked.

"I only vanted it for Klaus—so he vuld take me back. He didn't love Toby, he never did," he said, shaking his head vigorously. "He loved me, only me. Toby was only an infatuation."

"Eighteen years is a long infatuation," McGuffin remarked.

"It vuld not have been so long vere it not for your boss," Kruger replied angrily. "He vas the villain. I hired Mr. Dwindling to steal the egg and deliver it to me, but he vas a greedy man. Not even I knew the combination to Klaus's safe—he vuld think that Toby vas the thief, not I. Then I vas going to find the egg in Toby's possession and return it to Klaus; then Klaus vuld throw Toby out and take me back! But your Mr. Dwindling ruined everything, so I killed him! And now ven I had another chance for happiness you haf ruined it again—you haf killed the only man I ever loved!" he wailed as the tears coursed freely down both cheeks.

"I told you, it wasn't me," McGuffin protested. "And it wasn't me who stole the egg, it was Dwindling. But he's dead and so are a lot of other people because of the goddamned thing. So unless you want to make it one more, tell me, what have you done with them?" McGuffin demanded as he sighted down the barrel at the old man's head.

Kruger wiped his eyes with the sleeve of his kimono, then looked up at McGuffin with a thin smile. "Do you think I can be threatened by death ven I haf lost the only thing in life that mattered to me?"

"How about pain?" McGuffin asked, replacing the gun in his coat pocket. "A pain nearly as equal to the mental anguish you've caused me as I can make it. Get up."

"Vut are you going to do?" Kruger asked, pressing back against the pillows.

"You're going to the oven," McGuffen said. "Sound familiar? I'm gonna crank it up to about five hundred degrees and then I'm gonna bake you, one piece at a time, until you're nicely charred on the outside and pink and juicy on the inside. And if that doesn't get me the answer I'm looking for, I'm gonna get mean."

"Barbarian!" the old man gasped.

"Up," McGuffin said, motioning with his fingers.

Kruger lifted his chin and looked down his nose at his tormentor. Please, God, let him fold, McGuffin prayed. He watched in stunned disbelief as the old man fumbled with the pillows and struggled to rise. He's going to make me do it!

Kruger got to his knees, flung his arms wide and exclaimed, "Let this, too, be on your conscience!"

The bayonet flashed briefly in the amber light as it appeared from the billowy fold of a kimono sleeve, then disappeared near the point where the lapels crossed his chest. He uttered a short plosive sound and fell forward, driving the long knife through his body and out his back. The bayonet had been under the pillow, McGuffin

quickly realized. He must have intended to kill himself if Klaus had spurned his love.

"May God damn you," McGuffin said, then turned and walked slowly out of the room.

11

The woman at the auto rental desk stared fearfully at the man pushing through the glass door. A bloody bandage peeked out from under his wet felt hat; he wore an Arafat beard and a trench coat that he must have wrestled from a wino; and he seemed intent on rape and murder. He stopped in front of her, reached under his damp, blood-stained coat and came out with an envelope.

"I'm returning the car," he said, pointing a thumb over his shoulder.

"Car—?" she repeated, looking through the window at the car at the curb, its upholstery in shreds, the seat cushion poking through the rear window. He's a customer! she realized.

"I'm afraid there's been a little damage, so if you'd like me to fill out an accident—"

"It's quite all right," she interrupted. "If you'll just sign here I'll take care of everything."

McGuffin shrugged, then reached across the desk for the contract. "I wish I had been with your company the last time something like this happened to me."

"The last time—?" she asked.

"In Los Angeles," McGuffin said, as he read what he was signing. "Some surfers pushed my car into the ocean, so I had to get a replacement. Then some Arabs pushed that one off a cliff on Mulholland Drive. The president of the company threatened to sue me and to fire anyone who ever rented me a car again," he said, as he signed his name.

"What company was that, sir?" she asked, taking the contract from him.

"I've forgotten the name of the company, but the president's name was Worthy."

"Not Ronald Worthy!" she gasped.

"Gee, I'm sorry," McGuffin said.

She shrugged. "I was about to quit anyway."

"Sorry," McGuffin said again, then hurried out of the office.

She waited until he had gotten into a cab and driven off, then went outside to examine the car. She didn't understand it. It was obvious from his bloodied head and the trashed interior of the car that the man had been in a terrible accident—yet the outside of the car didn't have so much as a scratch on it.

Goody was nodding off at a table in the back of the saloon when McGuffin limped in. He opened his eyes slowly and stared at the bedraggled detective as he dropped heavily onto the last barstool. "If I didn't know you was on a case, I'd say you been on one hell of a tear," Goody observed.

"I feel like it," McGuffin replied.

"You didn't find 'em?"

McGuffin shook his head slowly. "I've run my string; I'm calling in the feds." He removed his hat and let it fall like a defective parachute to the bar. "Where's Sully?"

"He got called downtown—on account of you. They come up with a couple of more stiffs in Napa which

they're layin' on you, and Sullivan's boss thinks he might be coverin' for you."

"If he is he can quit," McGuffin said, reaching into his coat pocket for his automatic, which he laid on the bar beside his rain hat. "I'm turning myself in just as soon as I've filed a Missing Persons report."

When he turned, Goody asked, "What happened to your head?"

"A bullet hit it."

"Oh," Goody said, climbing to his feet. "You want some coffee?"

"Just a little—with a lot of Paddy's. I'm off the case," he added, before Goody could object. "All I have to do now is phone the FBI and I can do that drunk. Do you think those goddamned tax eaters get in before nine?" he asked, glancing at his watch. It had stopped at about the same time Otto Kruger's heart had stopped.

"I doubt it," Goody said, as he waddled stiffly to the hotplate behind the bar. He poured three fingers of coffee into a beer glass and filled the rest with Irish whiskey.

"No whipped cream?" McGuffin asked, as he reached for the glass.

"This ain't the fuckin' Buena Vista," the barkeep growled. "And if I was you I'd shave before I turned myself in," he warned. "You get your picture in the paper lookin' like that and you're dead. There's a razor in the toilet."

McGuffin stroked his beard and stared at his hollow eyes in the mirror, the eyes of a killer. He who had never before even fired a gun at anyone had killed three people in the last twenty-four hours and he felt nothing, absolutely nothing. Maybe later, when I have Marilyn and Hillary, I'll feel something, he thought, as he lifted the glass to his lips. The coffee and whiskey fell on his empty stomach like a hammer. He waited for the pleasant numbing sensation that would follow, but it didn't come. Instead a sickness rose in his throat and crawled through his body.

He pushed the drink aside and climbed unsteadily to his feet.

"You okay?" Goody asked, as McGuffin lurched to the phone.

"Just tired," McGuffin answered. "Gonna call Missing Persons."

Goody waited and listened while McGuffin filed a lengthy report, first with the San Francisco Police Department, then the Federal Bureau of Investigation. He had a hard time convincing the federal clerk that it was within his jurisdiction, and came close several times to blowing up. "I'm trying to tell you," he said, in a voice barely concealing his restrained anger, "that they did not just wander off, they were kidnapped by Otto Kruger who killed himself before telling me where he was holding them." Eventually the clerk decided that the matter might warrant the assignment of an agent and promised that one would phone shortly. "Thank you," McGuffin sighed.

He replaced the receiver on the hook and walked slowly back to the bar. "Done," he said, resting heavily on his elbows. "Now all I have to do is turn myself in."

"You want I should call O'Brian?" Goody asked.

"Would you?" McGuffin asked.

"Sure," Goody said, turning to the cash register. He perched his reading glasses on his nose and leafed through a stack of business cards and scribbled messages, stopping suddenly at a yellow scrap of paper. "I almost forgot, your landlord called yesterday."

"Probably renewing eviction proceedings," McGuffin grumbled as he reached for his coffee and whiskey.

"He said it was important—maybe he knows something about Hillary," Goody suggested.

Knowing better, McGuffin slid off the barstool and walked back to the phone. As expected, Elmo was annoyed at the recent homicide aboard the *Oakland Queen*.

"Are you trying to ruin me, is that it?" he wailed, after McGuffin had identified himself.

"If that's all you're calling about I'll have to hang up," McGuffin said.

"Whattaya mean all? You kill a guy on my boat and I don't even get an apology?"

"The matter is pending in court, all I can say is good-bye, Elmo."

"Wait!" Elmo shouted. "I wasn't callin' about that. I was callin' about that night the cops jumped me when I was trying to bust into your office."

"What about it?"

"I just wanted you to know that that's not my style, Amos. I didn't go there with the intention of bustin' in, I was just gonna throw all your stuff in the storage room off the boat—as sort of a warning, that's all. But then I came across this black leather bag with a lot of tools and shit in it and that's when I got the idea to bust in."

"You took the bag?" McGuffin interrupted.

"I didn't take it, I just borrowed it," Elmo corrected. "No big deal, I'll bring it back. Hell, you probably didn't even know it was missing."

"As a matter of fact, I did notice it was missing," McGuffin said. "But you're right, it's no big deal—I thought the KGB had taken it."

"That's not funny," Elmo said.

"You're right, it wasn't. So long, Elmo."

"Good luck," Elmo replied.

McGuffin replaced the receiver on the hook as Sullivan charged through the door, saw him and shouted, "What the fuck do you think you're doin', McGuffin?"

"He's makin' a phone call," Goody answered.

"It better be to a lawyer! Did you kill those two guys in Napa?" he demanded.

"It was self-defense," McGuffin answered wearily.

"What about the old guy in the kimono?"

"Hara-kiri."

"And the guy on your boat and the couple in the apartment on Leavenworth—? Jesus Christ, Amos, not even the fuckin' hillside strangler does six in one night!"

"I only did three," McGuffin replied.

"He had a bad night," Goody said. "Leave him alone."

"What about me? You think I'm havin' a good night with everybody bustin' my chops to find him and bring him in?"

"So you found him, relax. He didn't murder nobody, you know that," Goody chided the cop.

"I ain't sayin' he's a murderer!" Sullivan protested. "But when somebody abducts your wife and daughter and then six people turn up dead, you gotta admit there's at least a hint of suspicion. I mean you can't blame the Commissioner for wantin' to ask him a couple of questions."

"And I'm ready to answer them," McGuffin said, thrusting his hands out in front of him. "You want to put the cuffs on me? Will that make you look good for the Commissioner?"

"I'm not tryin'—ah, forget it," he said, turning to Goody. "Let's all have a drink and then we'll take McGuffin to jail."

"Good idea," Goody said, slamming two more glasses on the bar.

McGuffin walked listlessly to the bar and sat beside the big cop while Goody poured. Sullivan turned and studied the bloody handkerchief sticking to McGuffin's head, then asked, "What happened?"

"I got shot."

"Good," he said with a satisfied nod. "I mean it's good evidence for a self-defense," he quickly amended.

"I know what you meant," McGuffin said, as Goody pushed Sullivan's drink across the bar.

Sullivan's hand all but concealed his drink. "Does it hurt?" he asked, taking another look.

"Only when I think."

"Be grateful for that," the cop said, hoisting his glass. "To the successful if messy conclusion of still another baf-

fling case by the brilliant and dashing San Francisco private—" He stopped. "You did find them, didn't you?"

McGuffin shook his head. "Not yet."

"What!" he exclaimed, looking from McGuffin to Goody. "They're still missing and you want me to take you in?"

McGuffin shrugged. "I've reported them. There's nothing more I can do."

"Whattaya mean, nothin' more? We'll get in the car and go look for 'em! We'll take this fuckin' town apart brick by brick!" he exclaimed, waving and splashing his drink.

"I've been everywhere, I don't know where else to look," McGuffin replied wearily.

"They gotta be somewhere!" Sullivan said, as the phone rang. He continued to harangue McGuffin—"I'm willin' to put my career on the line and all you do is sit here!"—while Goody went to the phone.

"I made a mistake, I should have reported it to the FBI right at the beginning," McGuffin lamented.

"McGuffin!" Goody shouted.

"What?"

"It's Marilyn!"

"Marilyn—? Marilyn!" McGuffin shouted, stumbling from the stool and rushing to the phone. He snatched the receiver from Goody's hand and babbled excitedly, "Marilyn, is that you? Where are you, are you all right?"

"Amos, please, you don't have to shout," his former wife replied calmly.

"Hilly—how's Hilly?" he stammered.

"Hilly is fine."

"Thank God, oh, thank God," McGuffin gasped.

"Amos, are you all right?" she inquired.

"Never mind me. Did he hurt you—did he hurt either of you?"

"Did who hurt me?" she asked.

"Otto Kruger, the man who abducted you."

"My God, you're drunk," she said. "It must be what

179

—about ten o'clock in San Francisco and you're drunk already?"

"I'm not drunk. I haven't had a drink since you and Hillary disappeared. And what do you mean, 'about ten o'clock in San Francisco'? Where are you calling from?"

"New York."

"New York! He took you to New York?"

"Who?"

"Otto Kruger!"

"Who the hell is Otto Kruger?" she shouted across the continent. "And if you say the man who abducted me, so help me, Amos, I'll hang up!"

"No, don't hang up!" McGuffin pleaded. "Please, don't hang up. Just tell me what you're doing in New York."

"Auditioning."

"Auditioning—?"

"Congratulate me, Amos, I've been accepted in the Actors Company!"

"The Actors Company."

"Amos, why do you keep repeating everything I say?"

"I'm sorry, just bear with me a moment. You're telling me that you went to New York of your own free will, that no one abducted you?"

"Amos—," she warned.

"Marilyn, if you weren't abducted, who the hell was the old man who came to the apartment and took you and Hillary away in the car?"

"Otto Kruger—?"

"Yes!" McGuffin exclaimed.

"I'm kidding," she said. "How would I know who he is? He was just some guy the airport limousine service sent."

"But Mrs. Della told me he forced Hillary into the car! What kind of chauffeur is that?" McGuffin demanded.

"That's ridiculous!" she protested. Then in a softer

voice, "I'll admit that she might not have been all that excited about the idea, but—"

"Then what about the newspaper clipping of the Dwindling murder trial?" McGuffin interrupted, while Goody and Sullivan stared raptly. "How did it get on top of your chest of drawers?"

"Oh, that," she said, followed by a pause which, McGuffin knew, meant she was drinking coffee. "I found it in the bottom of that old leather suitcase of yours when I was packing. It must have been there for twenty years."

"Eighteen," McGuffin corrected. "Then you weren't abducted."

"Amos—"

"You went to New York to audition for the Actors Company."

"And I've been accepted! I've got a part in *The Cherry Orchard*!" she said excitedly. "Of course it's not a very big part, but it's a part just the same, and I'm told that new members don't often get—"

"Let me talk to Hillary," McGuffin interrupted.

"She just left for school."

"School—?"

"P.S. forty-one."

McGuffin breathed deeply to ward off hyperventilation, then inquired in a calm voice, "You enrolled her in school in New York—with numbers?"

"Um-hmm," she answered, drinking coffee. "Right near where we live. We got this darling little sublet in Greenwich Village, kind of scroungy but very bohemian."

"For how long?" McGuffin asked, straining for control.

"A year."

"You intend to remain in New York for one year?"

"Or longer. Amos, my career has finally taken off. I can feel it!"

"Marilyn, are you aware that we have a custody agreement?"

"Well, yes, but—"

"And that custody agreement provides that you cannot remove Hillary from the state without my consent?"

"But this came up suddenly, I couldn't find you."

"Well, now you have and I want Hillary out of P.S. whatever number and on the next plane back to San Francisco, do you understand?"

"Amos, we were suffocating in San Francisco," she complained.

"*You* were suffocating, Hillary was thriving!"

"Amos, if you don't stop shouting—"

"And don't you threaten me, Marilyn, not you! You have no idea what you put me through. I killed three people, I got shot in the head and I stole an egg worth millions of dollars!"

"You are drunk," she said.

"Why couldn't you have left a note?"

"We were in a hurry."

"Or phoned?"

"You wouldn't accept the charges."

"That wasn't me, that was—! Never mind, that's not the point! The point is I want Hillary back or I'm going to court and don't think I won't, because I have to go to court anyway for killing those three guys!"

"Amos, you're being preposterous," she interrupted impatiently.

"I'm being preposterous? I'm not the one who abducted our child!"

"Very well, if you're going to take that attitude—," she said, and the phone went dead.

"Don't you hang up!" McGuffin shouted at the useless instrument. Then, slamming the receiver on the hook, he hollered, "Shit!"

Goody and Sullivan watched wordlessly as McGuffin, uttering vile expletives and dire threats, lunged across the room to the bar. "They weren't kidnapped?" Sullivan asked. "They're okay?" Goody asked at the same time.

"They're fine," McGuffin said, plopping his rain hat on his head.

"Where you goin'?" Sully asked.

"To New York," McGuffin answered, glancing at his reflection in the mirror.

"Whattaya, nuts? You think you can kill three people and go to New York without at least stoppin' by the DA's office?" he asked, sliding off the barstool.

"I'll be back in twenty-four hours," McGuffin promised. He would shave at the airport.

"Sorry, Amos, you're comin' with me," the big man said, advancing on McGuffin.

"Hey, what is this?" McGuffin asked, backing away. "Just a minute ago we were going to take San Francisco apart brick by brick, remember?"

"That was before we knew where they were. This is now and I gotta take you in," he said, motioning McGuffin toward him.

When McGuffin spun for the door, Sullivan lunged, missing his arm but managing to come away with a handful of damp sleeve.

"Let go!" McGuffin shouted, straining to reach the door, while Sullivan, heels dug in, grunted, "Stop pullin'!" When, a split second later, the sleeve came away from the shoulder with a loud rip, both men were propelled forward with unexpected speed, McGuffin through the front door, Sullivan to and along the floor, striking his head finally on the brass rail at the foot of the bar.

"Sully!" Goody shouted, reaching for the cop's drink.

Sullivan was awakened by the taste of whiskey and the sight of the barkeep on his knees beside him, holding the glass to his lips. "What are you doin'?"

"Giving you a drink."

"Some service," he grunted, struggling to one elbow. He took the glass from Goody's hand and finished the drink in a gulp. "Where is he?"

"On his way to New York."

"Dumb bastard. Help me up."

Goody climbed to his feet, pulled the much larger

man up after, then watched while the cop probed at his head. "You okay?" he asked.

Sullivan nodded. "How long's he been gone?"

"A few minutes," he answered, watching as Sullivan walked unsteadily to the phone. "What are you gonna do?"

"Whattaya think I'm gonna do?"

"Let him go, Sully."

"You're as nutty as he is," Sullivan said, reaching for the phone. "He's resisted arrest, there's nothin' I can do."

"Nobody has to know that," Goody pointed out.

"You're askin' too much," the cop said, fumbling in his pocket for a quarter.

"McGuffin's a fuck-up, but he ain't stupid," Goody said, following Sullivan to the phone. "He ain't gonna go to New York, I guarantee you that. He'll be back just as soon as he cools down, I bet you five hundred dollars."

"Can't take the chance," Sullivan said, coming up with a quarter. He dropped it in the slot and began to dial as Goody continued to plead for McGuffin.

"Just give him an hour."

Sullivan finished dialing, turned to Goody and shook his head. "Yeah, it's Sullivan," he spoke into the phone. "Let me talk to the old man."

"Think what you're doin', Sully. He'll lose his license, he'll be ruined."

"And I'll lose my pension," the cop said over a covered mouthpiece.

"Just an hour," Goody pleaded.

"Yes, sir," Sullivan replied smartly as he lifted his hand from the mouthpiece.

"Fascist," Goody muttered.

"No, I haven't found him yet, sir, but I think I should, very soon." Goody smiled as much as he ever does. "How soon—? Within the hour, sir."

Goody had a second drink standing on the bar when Sullivan finished his call. The cop sat heavily on the bar-

stool, lifted his glass and pointed it at the clock. "One hour," he said.

"One hour," Goody replied confidently.

One hour later Sullivan was drunk, Goody was out five hundred dollars, and a man with a bandaged head and Arafat beard, carrying an egg in his one-sleeved raincoat, was on an airplane bound for New York City. Preoccupied as he was, the detective was scarcely aware of his fastidious seatmate, who glanced up occasionally from the glossy pages of *Connoisseur* to regard him with a look of utter distaste. McGuffin was pondering the events (it could hardly be called a case) of the last several days. Until then he had never killed anyone, and now six people were dead. Six people, and there hadn't even been a crime!

When McGuffin angrily slammed the armrest, his fellow passenger fixed him with a contemptuous look that McGuffin failed to notice. His attention was focused on the open magazine on the man's lap.

"What's that?" McGuffin demanded.

"It happens to be a Fabergé egg," the gentleman loftily and condescendingly informed him.

McGuffin looked at it and nodded knowingly. "It's not as nice as mine," he said, patting the pocket of his grubby coat.

"Indeed," the gentleman sniffed, turning a shoulder to McGuffin.

After McGuffin had showed him the Fabergé egg, the man said nothing more during the rest of the flight.